IMAGES
of America

BATTLE CREEK

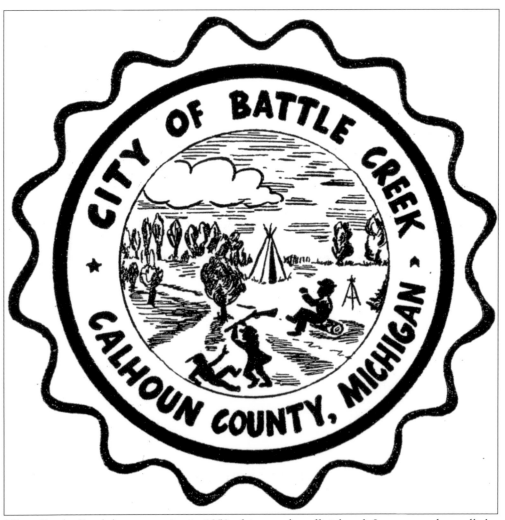

When Battle Creek became a city in 1859, this was the official seal. It attempted to tell the story of the "battle" of Battle Creek. Its crude depiction of a Native American being bludgeoned by a surveyor was displayed on all official documents until the early 1980s.

The story of the actual event is hard to piece together, but the basic account is that in March of 1825, two surveyors, sent to survey the Michigan Territory, were left in camp while the rest of their team, led by colonel John H. Mullet, were off surveying. Two Native Americans came into camp and requested food, which was customary in their society—people shared whatever they had. After they had eaten, they requested information about what the surveyors were doing in this part of the wilderness and how many were in their group.

The two Native Americans became agitated and ordered the white men to leave. When Mullet's men refused to leave, they attempted to force them. A fight ensued, which ended with the firing of guns and the natives being tied up. Colonel Mullett's party returned, and after questioning the natives, held them overnight (so they could not report back to their tribe), released them the next morning, broke camp, and returned to Detroit.

When it came time to assign a name to the creek they had been camping near, they thought it would be humorous to call it "Battle Creek."

On New Year's Eve, 1858, the city voted to call itself Battle Creek. The other choices were Calhoun City, Wopokisko, and Peninsular City.

IMAGES
of America

BATTLE CREEK

Kurt Thornton

ARCADIA

Copyright © 2004 by Kurt Thornton
ISBN 0-7385-3305-X

First Printed 2004
Reprinted 2004, 2005

Published by Arcadia Publishing
Charleston SC, Chicago IL, Portsmouth NH, San Francisco CA

Printed in Great Britain

Library of Congress Catalog Card Number: 2004106309

For all general information contact Arcadia Publishing at:
Telephone 843-853-2070
Fax 843-853-0044
E-mail sales@arcadiapublishing.com
For customer service and orders:
Toll-Free 1-888-313-2665

Visit us on the internet at http://www.arcadiapublishing.com

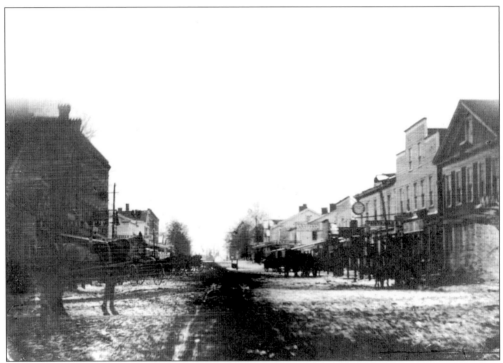

This photo, taken in the spring of 1853, is looking east on Main Street (now Michigan Avenue) from the corner of Jefferson (now Capital Avenue) and is considered the oldest photograph of Battle Creek. A small railing can be seen in the road marking the site of the Main Street Bridge over the millrace between East Canal (Monroe Street) and West Canal, (Madison Street) approximately where Mill Race Park is now located. (Courtesy of the Historical Society of Battle Creek.)

CONTENTS

ACKNOWLEDGMENTS

Wow, writing a book, even one with lots of pictures, is a lot of work. One of the positive aspects of this project was learning how to use the word processing program on the computer my sister, Diane, gave me. Another was getting to meet people who care about Battle Creek and have an interest in preserving its history. Some of the pictures in this book have been published before, but they are pretty good ones, so you get to see them again. Hopefully, in this format, all of the photographs—both familiar and unfamiliar—will work together to tell the story of this great city's history.

I want to recognize the people, books, and institutions that helped me with this project, because without them, you'd be looking at some blank pages. These resources and supporters include: Martin Ashley; my Battle Creek Health System Surgical Services co-workers (you're the best); the Battle Creek Historic District Commission *Walking Tour Brochures*; the Battle Creek *Sesquicentennial Book*; Diane Beckley; Thomas Bishop; Michael Breitbach; Maura Brown, my editor at Arcadia Publishing; John Buchmeier; Mike Buckley; Mary Butler; the 1869 Calhoun County Directory; Faye Clark's *As You Were—Fort Custer*; Ross Coller's *Battle Creek Centennial*; Fred Cummins' *Still on the Beat—History of Battle Creek Police Department*; S.S., the editor of the 1972 Battle Creek Central Key; Michael Gregory *The Forgotten Years of Battle Creek*; Janet Grey, St. Phillip Director of Education; Stacy, Jerry, Gabriel, Evan, and Lucy Hanna; Myra Heald; Heritage *Gold-in-Flakes*; the Historical Society of Battle Creek Archives; W.K. Kellogg Foundation; Brad Latty, Harper Run Communication Arts; George Livingston; Berenice Lowe; Larry Massie and Peter Schmit's *Battle Creek: The Place Behind the Product*; Barb Ramsey; Jane Ratner; *Religious Heritage—Greater Battle Creek Churches: 1832–1976*; Alfred G. Richards; E.W. Roberts; Susie Roeper; Marlene Steele; Joyce and Duff Stoltz; Louise Sweet, Art Center of Battle Creek; Kathy Thornton; the Willard Library Local History Collection.; and Dr. Theodore Yee.

Finally, I want to thank my parents, Frances and Junior Thornton. They taught me it was okay to love Battle Creek. Mom and Dad. . . . Thanks for the memories.

INTRODUCTION

Mention the words "Battle Creek" and one thing comes to mind: cereal. But Battle Creek has a history that goes back to a time before "snap, crackle, and pop."

Sands McCamly is sometimes considered the founder of the city, but early ownership of the area changed hands several times before the town was platted in 1836. In 1831, Lucius Lyon, Robert Clark, John J. Guernsey, and McCamly all had their eyes on the town site, but Lyon and Clark sold their interest to McCamly for $100 each. Guernsey eventually sold his interest to Nathaniel Barney, an innkeeper. McCamly dammed the Kalamazoo River and had a millrace dug through the town. With the arrival of mills, the village began to prosper. Some people settled out on the Goguac Prairie, an area southwest of town, along Territorial Road. It was an area that the Native Americans had kept cleared of trees by "burning off" the fields each year. By doing this, the natives were able to hunt easier. A deer running across a mile-wide field is much easier to hit with an arrow than a deer running through the trees. The settlers were mostly farmers and when they saw this large expanse of grassland, they thought it was an ideal place to plow and plant. The "savages" were forced to leave.

With the arrival of the railroad, the ability to manufacture items for exporting around the country became possible. Factories sprang up and the city's location between Detroit and Chicago helped make it a financial success. By the start of the Civil War, Battle Creek was becoming industrialized. The city became known nationwide for its threshing machines, steam pumps, and printing presses. Sojourner Truth, the world-famous human rights activist, made her home here. The Seventh Day Adventist Church moved to Battle Creek in 1861, and a health reform movement began. Soon after that came the accidental discovery of flaked cereal, making "Kellogg" a household name throughout the country, and the rest, as they say, is history.

In chapter one, "Business, Industry, and Government" (I call it the B.I.G. chapter), I've tried to choose photos that will illustrate the growth of the town's business and industry. It is also the "general" history of what happened from the first mill through the creation of the largest "ready to eat" breakfast food industry in the world.

Chapter two will show how education was an important part of the early settlers' beliefs, leading all the way up to the creation of a modern junior college. Chapter three deals with health and medicine and how the Battle Creek Sanitarium not only affected Battle Creek but spread the belief in a clean, "biological" lifestyle promoted by Ellen White and her followers that also ties in with chapter four, religion. The religious side of Battle Creek plays an important part in how the city viewed its spiritual self. In the 1970s, Battle Creek had more

churches and bars per capita than any other city in Michigan (as stated by my high school economics teacher).

I've tried to use pictures that give the viewer a "photographic memory" of Battle Creek. I've also tried to use the pictures in a chronological order but it was sometimes not possible. The images are from many sources, most of them are identified. Those that are unidentified were taken by myself or are from someone who wished to remain anonymous.

For more information about Battle Creek history, contact: Heritage Battle Creek (269) 965-2613, or Willard Library Local History Collection (269) 968-8166.

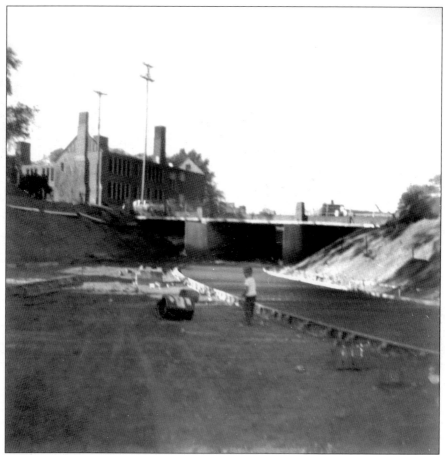

This is a photo of the author, Kurt Thornton, walking in the "new" cement Kalamazoo River diversion, c. November 1960. Frances Thornton, Kurt's mother, always wanted her family to be part of Battle Creek history. This view looks north towards the Upton Street Bridge. The building on the left is Jefferson Elementary School, which was being demolished as part of urban renewal.

One

BUSINESS, INDUSTRY, AND GOVERNMENT

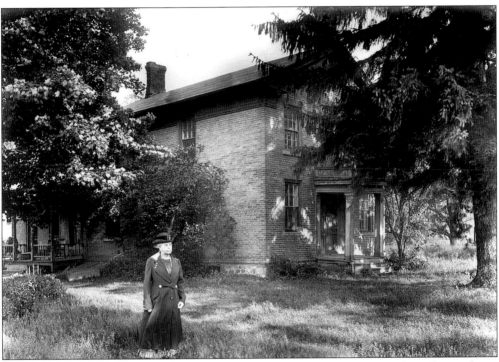

This is considered the oldest brick residence in Battle Creek and is located on the southeast corner of Coldwater Road (now Riverside Drive) and Territorial Road. It was built in 1852 as the home of Warren B. Shepard, the city's first schoolteacher. He only taught for one year, in 1834, and then married and became a farmer. His farm was part of a lawsuit filed against the city's founder, Sands McCamly. The dam, built by McCamly for the town's millrace, unintentionally flooded Shepard's land. Shepard won the lawsuit and maintained this home until his death on December 17, 1875. This photo of the house with Shepard's daughter, Emily, was taken in 1931.

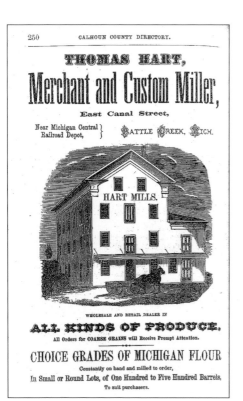

THOMAS HART,

Merchant and Custom Miller,

East Canal Street,

Near Michigan Central } BATTLE CREEK, MICH.
Railroad Depot, }

HART MILLS.

WHOLESALE AND RETAIL DEALER IN

ALL KINDS OF PRODUCE.

All Orders for COARSE GRAINS will Receive Prompt Attention.

CHOICE GRADES OF MICHIGAN FLOUR

Constantly on hand and milled to order,

In Small or Round Lots, of One Hundred to Five Hundred Barrels,

To suit purchasers.

Waterpower was the reason Sands McCamly chose the site for Battle Creek. In 1835 he had a millrace dug 1$^1/_4$ mile long and 40 feet wide to utilize the 2-foot drop between the Kalamazoo and Battle Creek rivers. One of the many early mills was the Hart Mill that ground "coarse grains" located on East Canal Street (now the lawn behind the W.K. Kellogg Foundation Building). (From the 1869 Calhoun County Directory, Courtesy of Dr. T. Yee.)

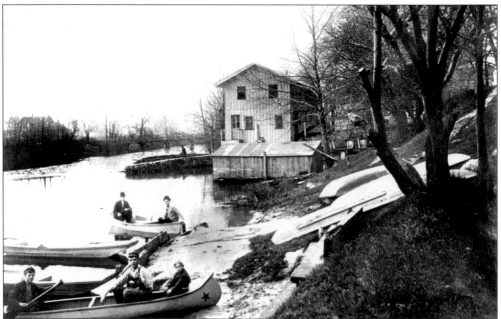

Ezra Convis constructed the Verona dam as a separate manufacturing area northeast of Battle Creek. Convis' dream for a city ended when he died in a sleighing accident. This photo shows the dam on the left looking south, down the river towards the wooden Emmett Street Bridge. The mill in the center of the photo is the Convis sawmill *c.* 1900. (Courtesy of the Historical Society of Battle Creek.)

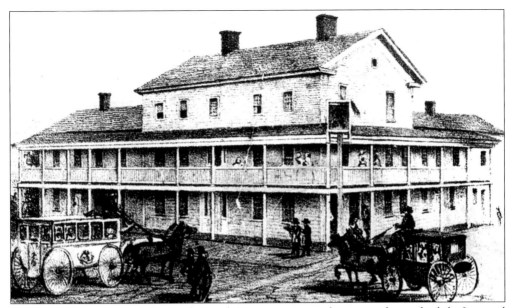

This c. 1869 drawing is of the Battle Creek House, an inn and stagecoach stop built by Leonard Starkweather in 1836 on the northwest corner of Main Street (now Michigan Avenue) and Jefferson Street (now Capital Avenue). In 1866 it burned to the ground. Reputedly, temperance fanatics who opposed the selling of "evil spirits" (alcohol) set the fire. (Courtesy of the Frances Thornton Collection.)

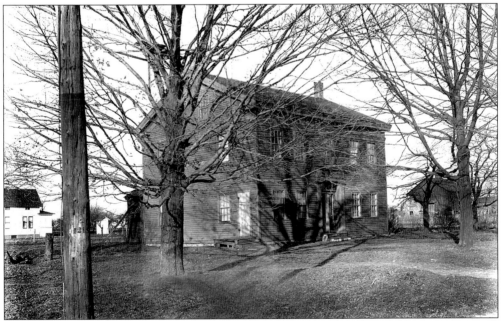

This is Barney's Tavern on the corner of West Michigan Avenue and Eldredge Street. It was built in 1838 as Nathaniel Barney's third inn and stagecoach stop. His first inn was at the confluence of the Battle Creek and Kalamazoo Rivers in 1834. This inn on the stagecoach route to Hastings was a center for many social events. There was room on the second floor for parties. This building is now used for apartments. The photo is c. 1930s. (Courtesy of the Frances Thornton Collection.)

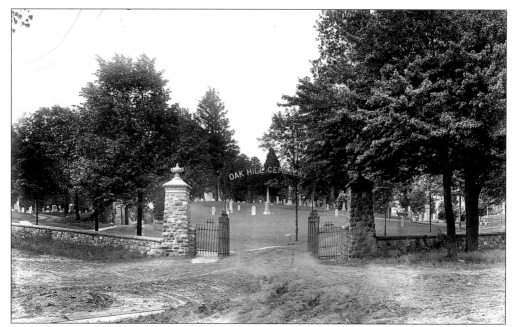

Oak Hill Cemetery was established in 1844 on the edge of town when the city began expanding. The older cemeteries located in Quaker Park (on Fremont Street) and on Washington Avenue (now the site of the Federal Center) were moved to the new location on South Avenue. Originally the cemetery only occupied ten acres, purchased for $120. In 1875 the local Catholic parish purchased land across the street for Mount Olivet Cemetery. The Oak Hill site now includes 75 acres. This photo of the South Avenue entrance was taken in the late 1800s. (Courtesy of the Frances Thornton Collection.)

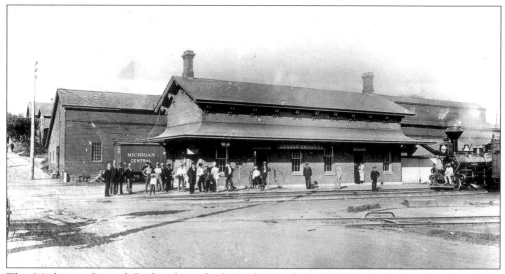

The Michigan Central Railroad reached Battle Creek in 1845. It helped make the city a manufacturing and commercial center. This is a photo taken c. 1861 of the first passenger station located near East Canal (now Monroe Street) on the north side of the river. The Kellogg House on the W.K. Kellogg Foundation grounds was the site of this building. (Courtesy of the Frances Thornton Collection.)

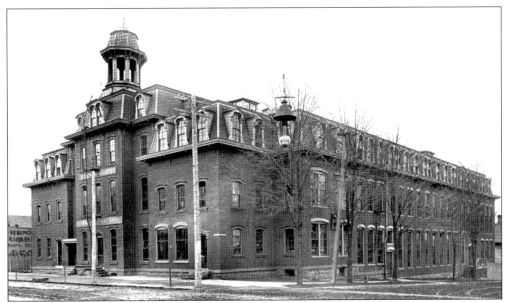

In 1855 the Seventh Day Adventists moved their printing company, the Review and Herald, from Rochester, New York, to Battle Creek. It was eventually the largest operation of its kind in Michigan with a monthly circulation of 40,000. This *c.* 1900 photo is of the building located on Main Street (now West Michigan Avenue) and Washington Avenue which burned on December 30, 1902. (Courtesy of the Historical Society of Battle Creek.)

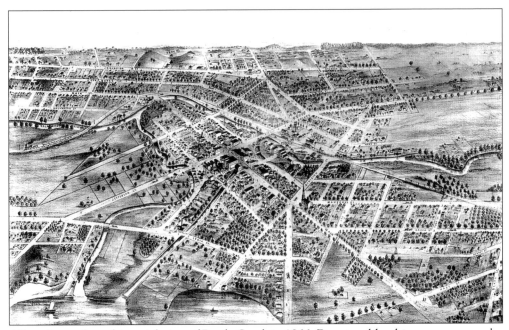

Albert Ruger drew this aerial view of Battle Creek in 1866. Drawings like this were very popular in the 1800s. This is a view of the city looking north from over the millpond. The First Methodist Church (on the pie-shaped lot where the present church is located) and Union School on McCamly Street (the location of the present high school music building) can easily be seen. (Courtesy of the Historical Society of Battle Creek.)

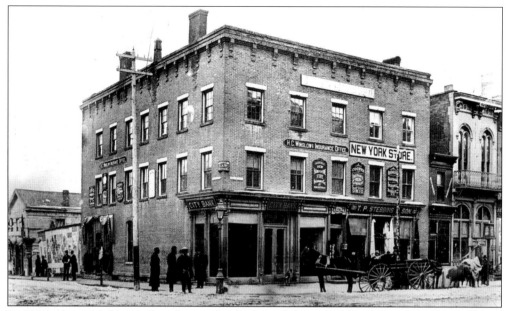

In 1837 Alonzo Noble purchased an unfinished wood frame building located on the southwest corner of Main Street (now Michigan Avenue) and Jefferson Street (now Capital Avenue) and started the second store in the village. In 1850 he had this brick building constructed. Some of its first tenants were the city's first downtown telegraph office, law offices, insurance offices, and a photography studio. This photo was taken in the winter of 1887. The horse and wagon are from the Review and Herald publishing company. (Courtesy of the Frances Thornton Collection.)

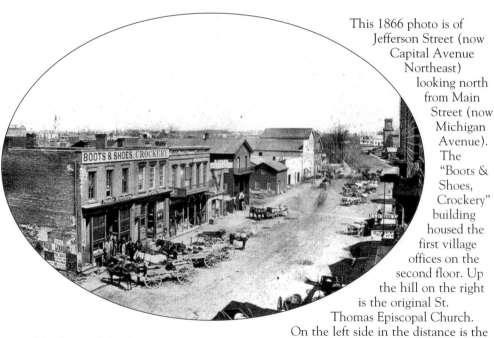

This 1866 photo is of Jefferson Street (now Capital Avenue Northeast) looking north from Main Street (now Michigan Avenue). The "Boots & Shoes, Crockery" building housed the first village offices on the second floor. Up the hill on the right is the original St. Thomas Episcopal Church. On the left side in the distance is the roof of the Union School. (Courtesy of the Frances Thornton Collection.)

In 1867 the town built its first city hall on Main Street (now West Michigan Avenue) on the present site of the Heritage Tower. It was a mansard roofed brick structure with three stories. The first floor was for the fire department's horses and city jail, the second floor was offices and county court room and the third floor was a large room for public meetings. The tower in back was built to contain the fire bell, watch for fires, and to dry out the fire department's water hoses. This photo was taken in the late 1800s. (Courtesy of the Frances Thornton Collection.)

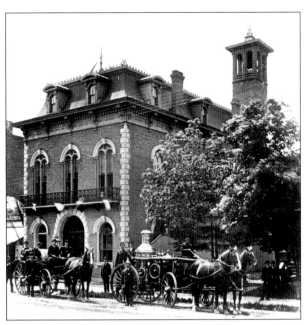

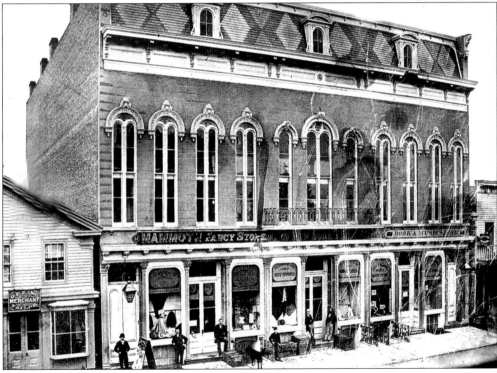

The Hamblin Opera House located on Main Street (now West Michigan Avenue) was opened January 1, 1869, at a cost of $40,000. It was the cultural center of the town for many years. There was room on the ground floor for retail shops, as shown in this c. late 1800s photo. The second floor contained the 1,200-seat auditorium that was considered the best-known vaudeville theater between Detroit and Chicago. The remodeled building is still standing and now houses the restaurant Birch. (Courtesy of the Frances Thornton Collection.)

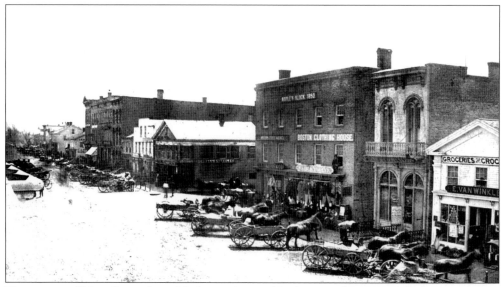

This view is of Main Street (now Michigan Avenue) looking southeast towards the intersection of Jefferson Street (now Capital Avenue) in the late 1860s. The Noble Block, on the southwest corner of the intersection, is in the center of the picture. (Courtesy of the Historical Society of Battle Creek.)

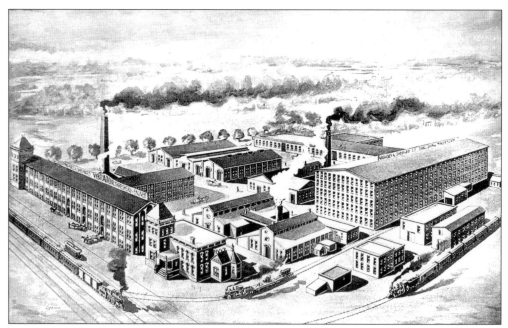

After returning from the California gold rush of 1849, Edwin Nichols and David Shepard founded a business manufacturing farm equipment; it was called the Nichols and Shepard Company. In 1854 they began producing steam engines and in 1859 they created the first vibrating threshing machines. To increase production of the machines they built this factory on Marshall Street (now East Michigan Avenue) in 1869. They merged with the Oliver Corporation in 1929 and closed in 1960. The last remnants of the factory are used as warehouses for Behnke Trucking. (Courtesy of the Historical Society of Battle Creek.)

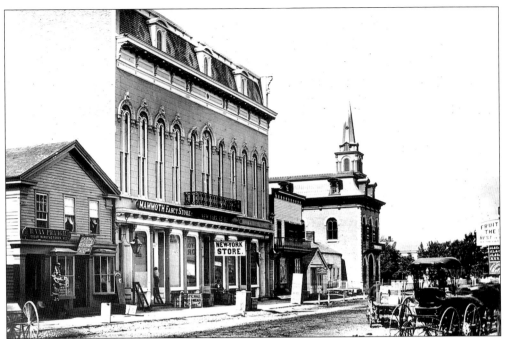

The Hamblin Opera House, city hall, and the tower of the Congregational/Presbyterian Church are visible in this 1869 photo of Main Street (now West Michigan Avenue) looking southwest from the corner of Jefferson Street (now Capital Avenue). (Courtesy of the Frances Thornton Collection.)

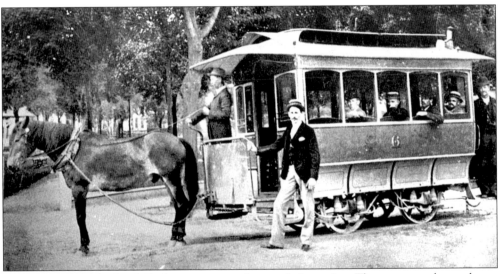

In 1883, the Battle Creek Railway streetcars began their service. The cars were horse-drawn and the company's owner was proud that wood stoves heated them all. The tracks ran from the Nichols and Shepard factory on Marshall Street (now East Michigan Avenue) to Beach Street (now Elm Street), along Green Street to Main Street (now Michigan Avenue) west until it reached Washington Avenue and the Battle Creek Sanitarium. The company had six cars and 24 horses. This undated photo was taken in front of McCamly Park. The horse's name is Maude and the driver is Johny Ayres. (Courtesy of the Frances Thornton Collection.)

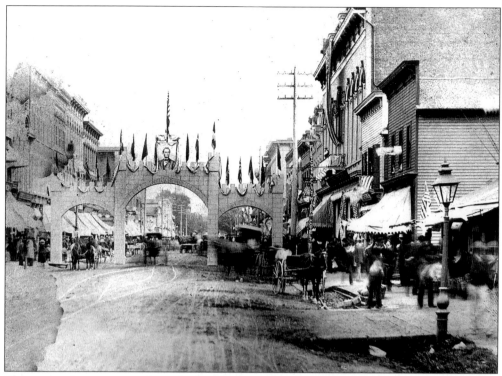

This undated street scene from the late 1800s looks east down Main Street (now Michigan Avenue) from in front of city hall (the site now occupied by Heritage Tower). The Hamblin Opera House is on the right, with a flag draped from the roof. The "Welcome" arch over the street depicts President Abraham Lincoln. (Courtesy of the Frances Thornton Collection.)

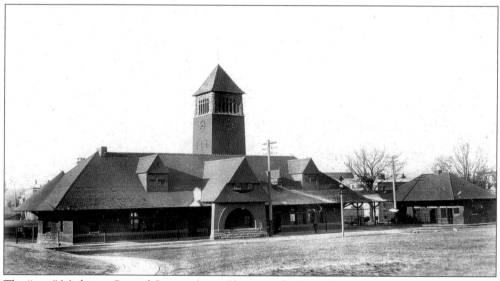

The "new" Michigan Central Station (now Clara's on the River) received its first passengers June 27, 1888. The Detroit firm of Rogers and McFarland designed the Romanesque style structure. It included separate ladies' and gentlemen's waiting rooms decorated in red oak. This photo of the north side of the station is from the late 1800s. (Courtesy of the Martin Ashley Collection.)

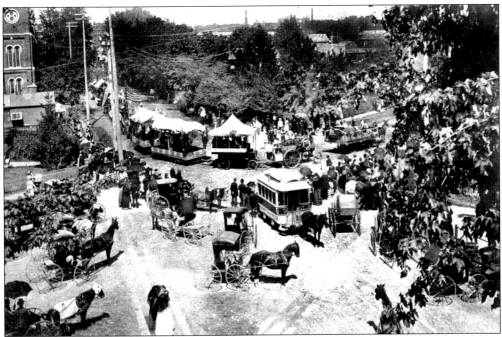

This is a photo of the 1888 Labor Day parade looking northwest from the corner of Main Street (now East Michigan Avenue) and Division Street in front of the present city hall. The present First Baptist Church can be seen on the left. (Courtesy of the Frances Thornton Collection.)

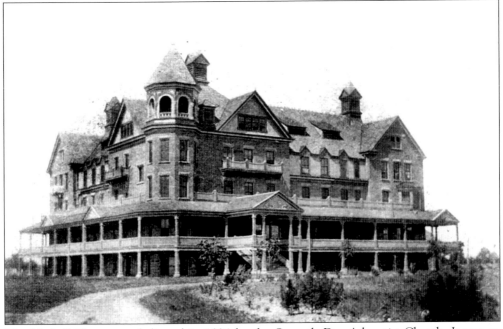

The Haskell Home was dedicated in 1894 by the Seventh Day Adventist Church. It was an orphanage with a capacity of 150 children. It was located near the site of the present Seventh Day Adventist Academy on Limit Street. Three children died in a fire that destroyed the building in 1909. This photo was taken approximately 1900. (Courtesy of the Frances Thornton Collection.)

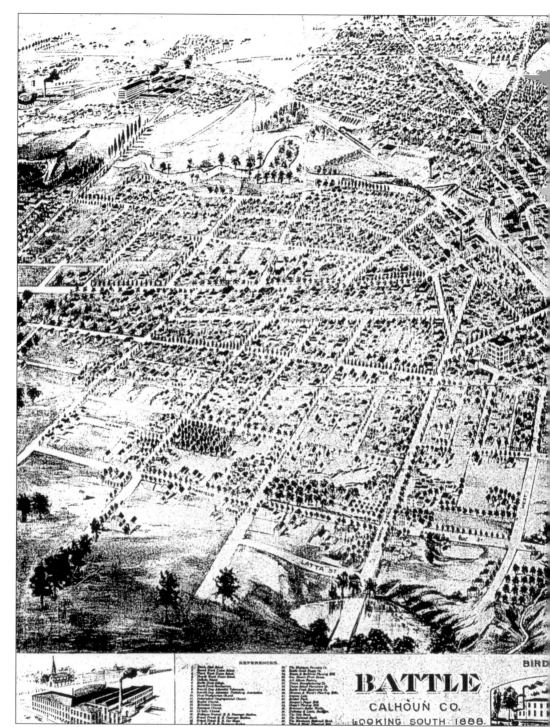

This is an 1888 aerial drawing of Battle Creek looking south from over the Battle Creek Sanitarium on North Washington Avenue. During a time before air travel, many cities had these created. This illustration was drawn by Eli Sheldon Glover, who had married Sarah Latta, the daughter of local real estate developer Alfred Latta. (The newly platted Latta Street is

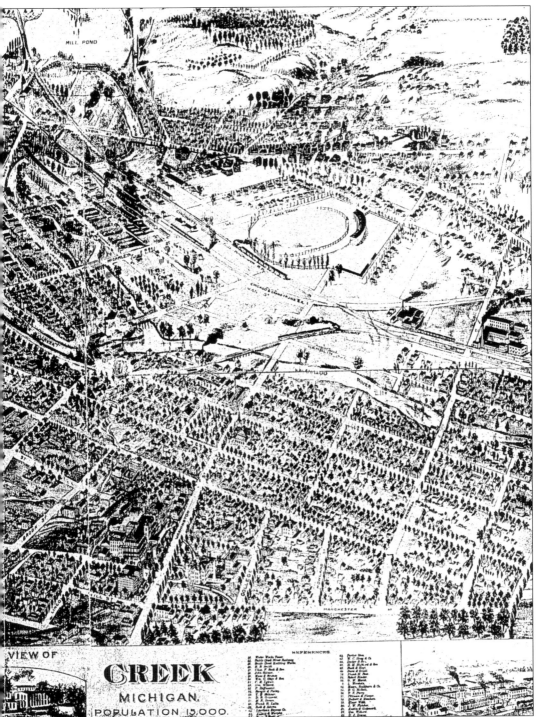

shown in the bottom left). The Battle Creek Driving Grounds can be seen at the upper right (now the location of car dealerships on Washington Avenue and Dickman Road) and the millpond is upper center. (Courtesy of the Historical Society of Battle Creek.)

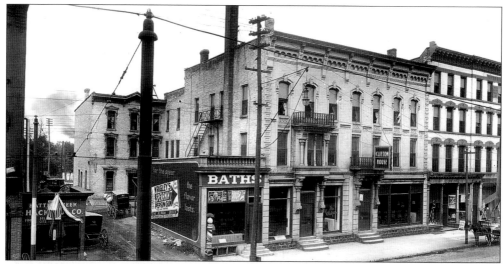

On April 30, 1880, the Potter House Hotel, located at 36-40 Main Street (now East Michigan Avenue) on the far right side of the picture, burned. It was rebuilt in 1881 at a cost of $20,000. The Chicago designer Edward Bowman planned the new hotel with the upper floors laid out in "french flats" with a central atrium for air circulation. In 1894 it joined the Williams House that was located on its east side. This photo is from the early 1890s; the Williams (Clifton) House was demolished in 1984. (Courtesy of the Historical Society of Battle Creek.)

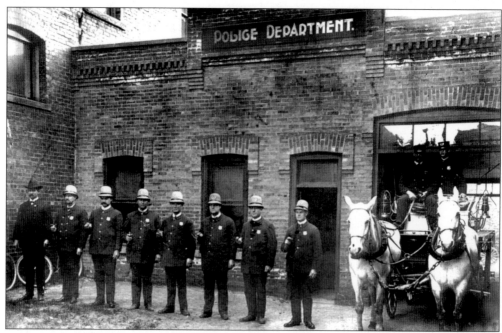

The city council voted to organize the Battle Creek Police Department on April 11, 1900. This photo, taken at that time, shows (from left to right): the first Police Chief, William H. Farrington; Captain James Bevier; Sidney Godsmark; Arthur Miller; Donald McDonald; Frank Niblett; George Colby; and Edward Edmunds. Seated in the wagon are Fred Gore and Henry Hodge. The horses were Barney and Roxie. The building was located behind the city hall on Main Street (now West Michigan Avenue). (Courtesy of the Historical Society of Battle Creek.)

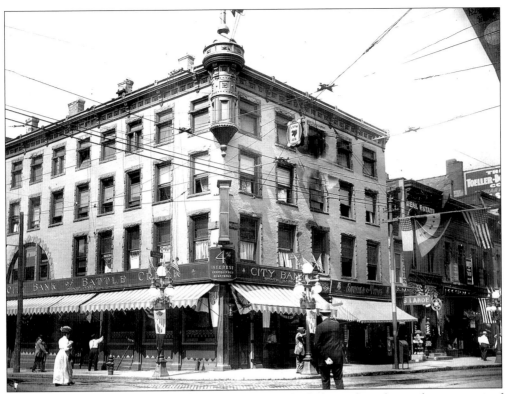

This photo, taken in 1913, shows the second Noble Block, located on the southwest corner of Main Street (now Michigan Avenue) and Jefferson Street (now Capital Avenue). It had the first elevator in Battle Creek, installed December 15, 1889, and it also housed the City Bank of Battle Creek. (Courtesy of the Frances Thornton Collection.)

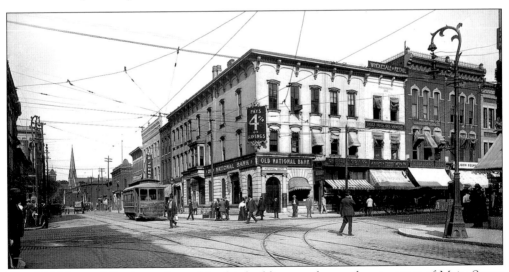

The Old National Bank was housed in this building on the northeast corner of Main Street (now Michigan Avenue) and Jefferson Street (now Capital Avenue), shown in this 1910 photo. This intersection has been known as the "bank corners" since that time. (Courtesy of the Historical Society of Battle Creek.)

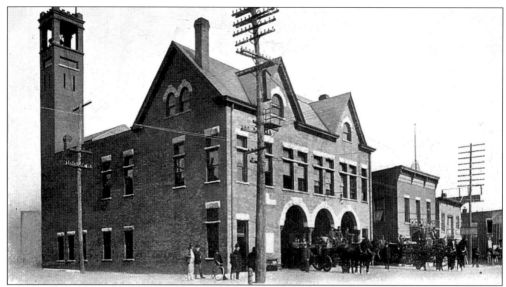

In November of 1846, after the Congregational/Presbyterian Church burned on Main Street (now West Michigan Avenue), the first firefighters were established in Battle Creek. The city's first fire station was housed in an old schoolhouse that, ironically, burned in 1866. This undated postcard shows Fire Station Number One, built in 1893, facing Jackson Street behind the old city hall. (Courtesy of the Frances Thornton Collection.)

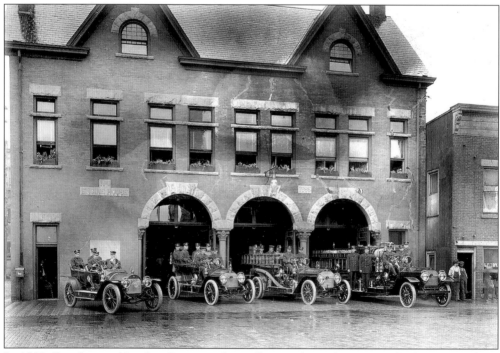

In 1901, Fire Station Number One was physically raised two feet to match the new grade of Jackson Street. The last firefighting horse was retired in 1917 and new fire engines were purchased and displayed as symbols of community pride, as shown in this undated photo in front of the Number One fire station. (Courtesy of the Frances Thornton Collection.)

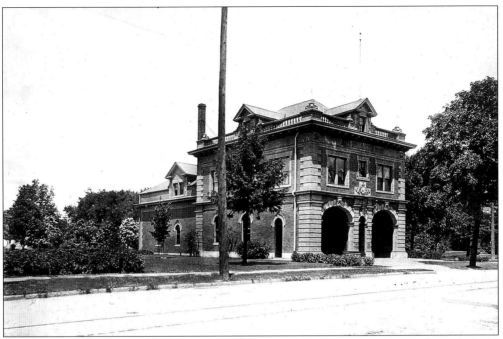

In 1903, at a cost of $9,100, this Number Two Fire Station was constructed on North Washington Avenue. It replaced the "old" Fire Station Number Two after the doors on the old building were found to be too small for the new fire engines. The old station was moved to Champion Street behind the high school. It was used as the GAR Hall, then housed Battle Creek Community College in the 1950s, and in the 1960s it was the Battle Creek Central High School Band Building before being demolished in 1972. (Courtesy of the Frances Thornton Collection.)

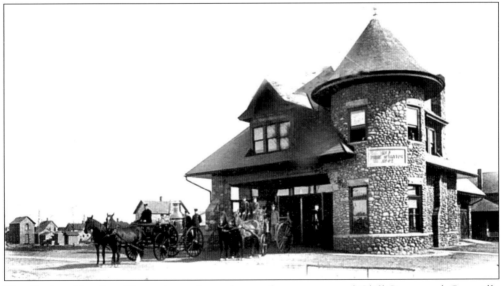

Fire Station Number Three, located on the southeast corner of Cliff Street and Grenville Street, was built on land donated by C.W. Post for "civic improvements for the neighborhood and factory." Herbert C. Scofield designed this building and a similar Fire Station Number Four on Kendall Street. (Courtesy of the Frances Thornton Collection.)

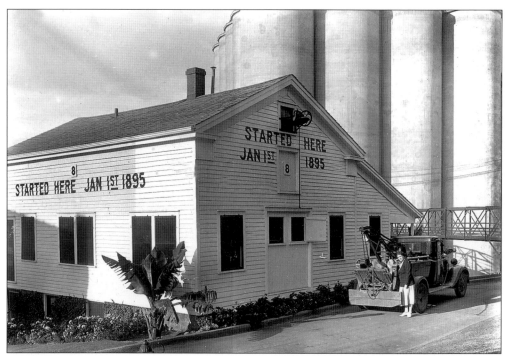

In 1895, C.W. Post began producing Postum (a coffee substitute) from this barn on Cliff Street. Post had been a patient at the Battle Creek Sanitarium where he was allowed to observe many of the food experiments going on at the time. Although he was never completely cured of his malady, he believed the way to health was through diet, exercise, and positive thinking. This photo was taken in the 1930s. (Courtesy of the Frances Thornton Collection.)

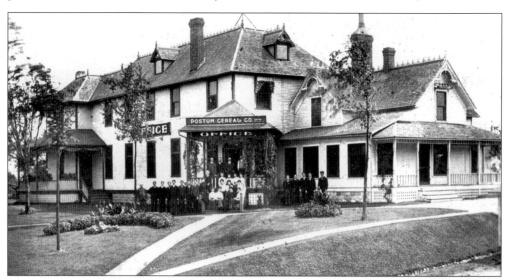

This is an 1899 photo of the sales and administrative employees on the steps of the Postum Cereal Company office building on the grounds of the Cliff Street cereal factory. C.W. Post tried to make it easy for his employees to purchase their own homes by providing an 80-acre subdivision he named the "Post Addition" adjacent to the factory. The affordable homes could be ppurchased through payroll deductions. (Courtesy of the Frances Thornton Collection.)

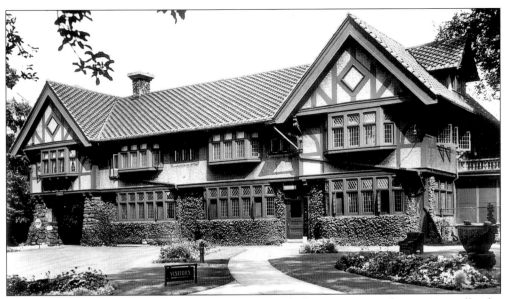

This English Tudor building on the Postum Cereal Company grounds was originally the Grandin Advertising building designed by Chicago architect Joseph Llewellyn. Post believed advertising was the way to build his cereal empire and invested a great deal of money in promoting his products. Post's private office was on the second floor of this building, which was eventually known as the Post Clubhouse. This photo was taken in the early 1900s. (Courtesy of the Frances Thornton Collection.)

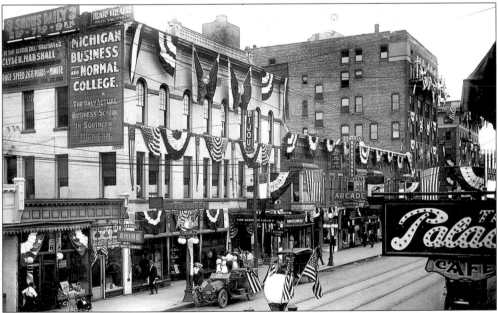

This 1913 photo is of Main Street (now West Michigan Avenue) looking west, showing preparations for a patriotic celebration. C.W. Post built the Post Building and Post Tavern as an office/hotel complex. Both structures are visible on the right side of the picture. The Bijou Theatre, in the center of the photo, was a popular vaudeville/movie theater downtown; it was demolished in the 1980s. (Courtesy of the Frances Thornton Collection.)

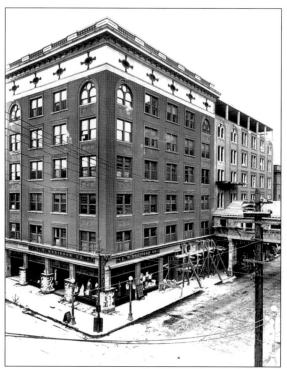

C.W. Post believed in Battle Creek and thought building an office/entertainment/hotel complex would promote his adopted city. In 1901, the Post Building on the southeast corner of McCamly Street and Main Street (now West Michigan Avenue), a state of the art office/retail facility was opened. It was the city's first "skyscraper" with the Athelstan Club (a social club) occupying the fifth and sixth floors. The business of L.W. Robinson, a longtime local merchant, was located on the lower level. This photo was taken in 1913 showing the Post Building addition and the enclosed bridge over McCamly Street to the Post Tavern being built. (Courtesy of the Frances Thornton Collection.)

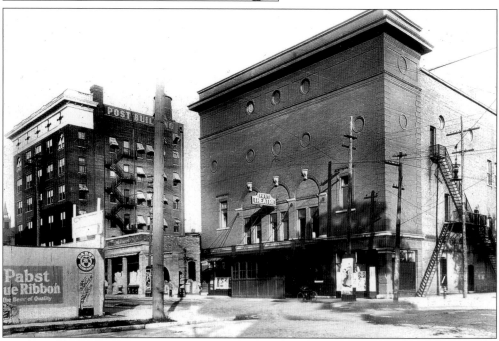

The Post Theatre was opened March 13, 1902, and billed as the finest legitimate playhouse between Detroit and Chicago. Its opening signaled the end of the Hamblin Opera House's preeminence as the city's cultural center. This undated postcard looks northeast from the corner of McCamly Street and Jackson Street. The theater was demolished in the late 1950s. (Courtesy of the Frances Thornton Collection.)

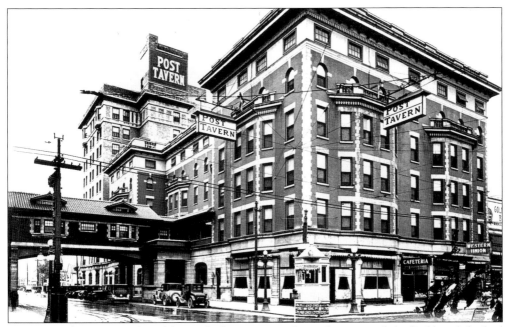

C.W. Post always remembered his early days as a traveling salesman and the bad hotels he had to stay in. In 1901 he built a first class hotel on the southwest corner of McCamly Street and Main Street (now West Michigan Avenue). He decorated the public areas with artwork from his private collection. because he wanted guests to remember with pleasure the most elegant hotel between Detroit and Chicago. This undated photo shows the ten-story addition that was built in 1912–1913. The whole Post complex of buildings was torn down by the 1980s. (Courtesy of the Frances Thornton Collection.)

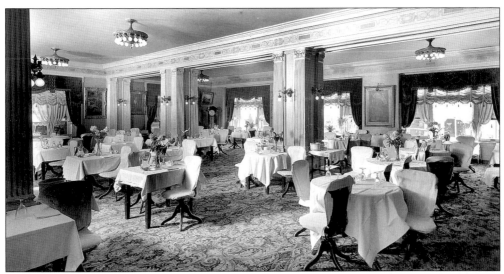

The Post Tavern's main dining room (as shown in this undated photo) was furnished with chairs designed by C.W. Post himself. The seats were made to tilt on springs because he wanted gentlemen to be able to "tip back their chair without making an awkward thing of it." They also swiveled side-to-side so a patron could swing away from the table without "pushing a clattering chair back." (Courtesy of the Martin Ashley Collection.)

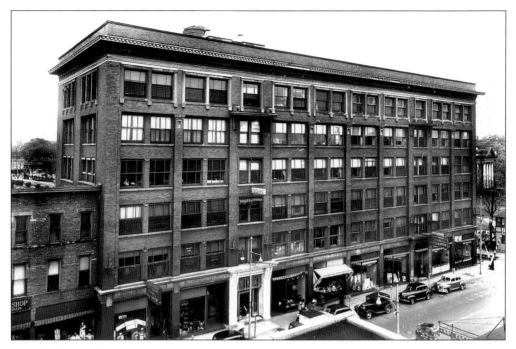

On October 10, 1905, the Ward Building (pictured above) opened on Jefferson Street (now Capital Avenue Northeast). It was the first steel and concrete fireproof building between Detroit and Chicago. This undated postcard (*below*) shows the view westward from the upper floor of the Ward Building. The Post Building and Post Tavern are on the far left; Michigan Central Station and Battle Creek river are in the right foreground with Number One school (now Battle Creek Central High School) on the upper right. (Courtesy of the Frances Thornton Collection.)

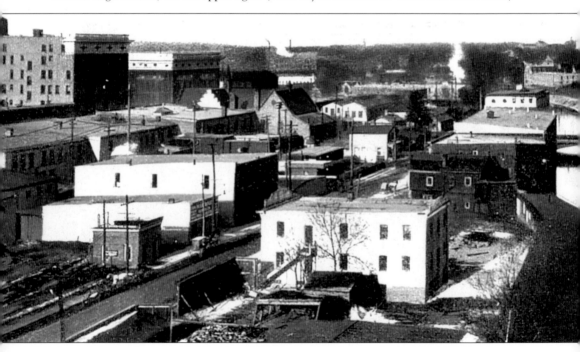

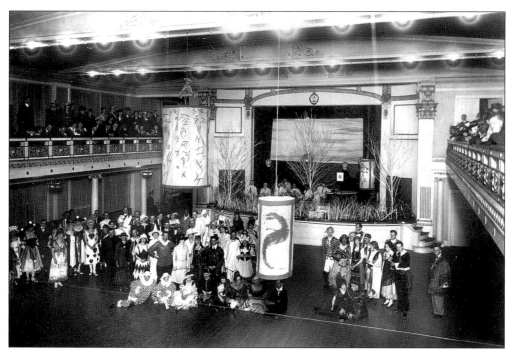

A local social group, the Athelstan Club, occupied the top three floors of the Ward Building. It included a men's lounge, poolroom, gymnasium, and auditorium/ballroom (seen in this undated photo). The parties and dances were popular social events in the city. In 1931 the Athelstan Club relocated to the Old Merchant National Bank Building because of the smoke from trains stopping at the Michigan Central Station. The building was demolished in the 1980s. (Courtesy of the Frances Thornton Collection.)

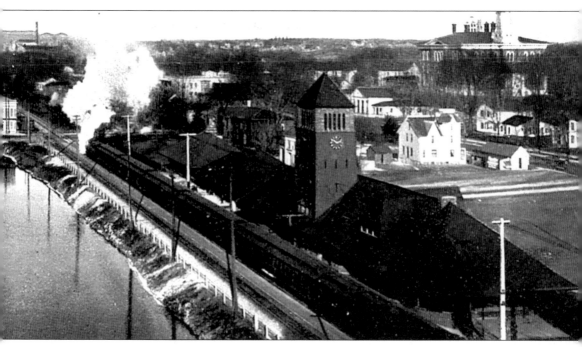

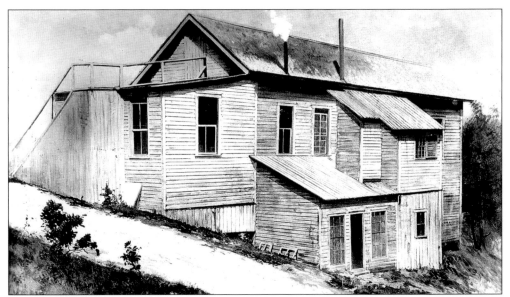

In 1894, by accident, Dr. John Harvey Kellogg and his brother, Will Keith Kellogg, invented flaked cereal. By 1902, over 40 companies were manufacturing cereal in Battle Creek. In 1906, W.K. Kellogg left his job assisting Dr. Kellogg at the Battle Creek Sanitarium and started the Battle Creek Toasted Cornflake Company. His first factory (shown here in the early 1900s) was located "under the hill, behind the San" on Brook Street. (Courtesy of the Frances Thornton Collection.)

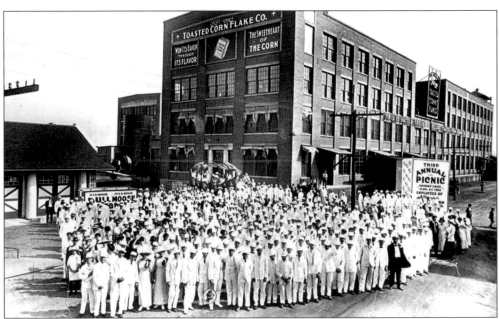

On July 4, 1907, W.K. Kellogg's second cereal factory on Bartlett Street burned down. In January of 1908, he moved his company into this factory building on Porter Street, designed by Chicago architect M.J. Morehouse. The company had changed its name to the Kellogg Toasted Cornflake Company. W.K. Kellogg wanted his employees to be happy, so he promoted many company events including this "third annual picnic" that included a parade through town then food, games, and fireworks at Goguac Lake. (Courtesy of the Frances Thornton Collection.)

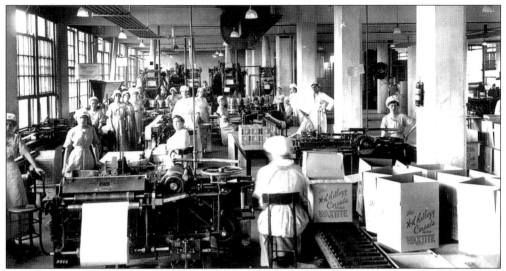

In the early years of the Kellogg Company, the majority of female employees worked in the packing room, as shown in this undated photo. By 1912, machines could automatically seal 630 cases in one nine-hour shift. During the Great Depression, Kellogg initiated a six-hour, six-day-per-week work shift to increase local employment. He also had daycare and medical care on site for his workers. (Courtesy of the Historical Society of Battle Creek.)

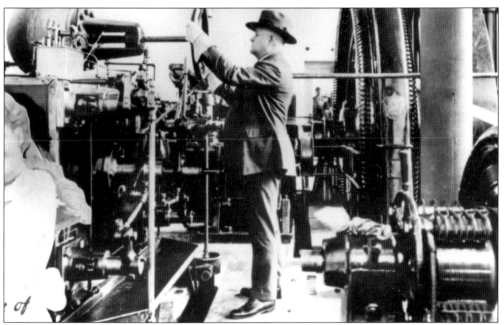

W.K. Kellogg started his business career selling brooms for his father. He then worked at the Battle Creek Sanitarium in the shadow of his famous brother, Dr. John Harvey Kellogg, for 25 years before starting his own company at the age of 46. His business became the largest cereal company in the world; he bequeathed a large part of his fortune to the W.K. Kellogg Foundation, which remains one of the largest philanthropic organizations in the United States. Kellogg loved machines and toured the factory several times a week, as shown here in this undated photo, examining equipment at the power plant.

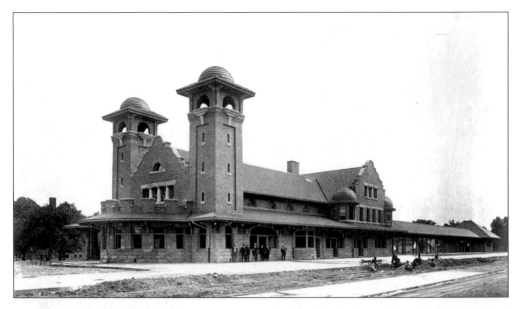

The Grand Trunk Passenger Station on Main Street (shown above in this photo) opened in January of 1906. It was designed by Detroit architects Spier and Rohn at a cost of $75,000. The waiting room (shown below in this postcard) was 57 feet by 94 feet with a 30-foot-high ceiling. The walls were covered with nine-foot-high white glazed tile wainscoting with mosaic floors. The construction of the station was controversial in that a boarding house that was in the way of construction had to be moved . . . but some of the tenants refused to leave. The railroad sent workmen to move the building on the weekend. Because the following Monday was a legal holiday, the tenants had no legal recourse until Tuesday, and by that time the building was moved. (Courtesy of the Historical Society of Battle Creek.)

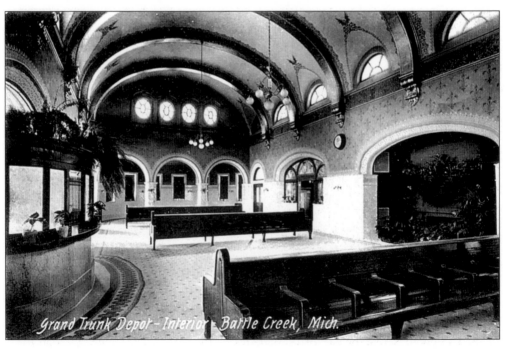

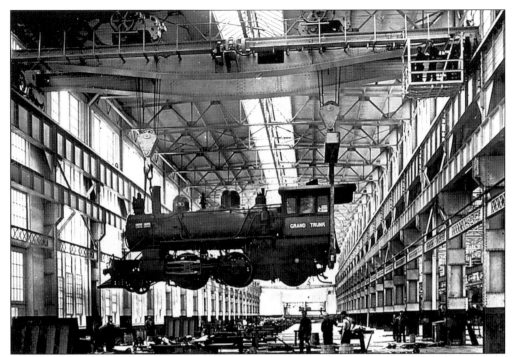

In 1908 the Grand Trunk Railroad Shop moved from Port Huron to Battle Creek. Arnold and Company Engineers were the designers of the 933-foot-long, 185-foot-wide building that cost $6 million to construct. At the time, it had the largest electric traveling crane in the country, capable of picking up a full-size steam engine, as shown in this 1908 postcard. (Courtesy of the Frances Thornton Collection.)

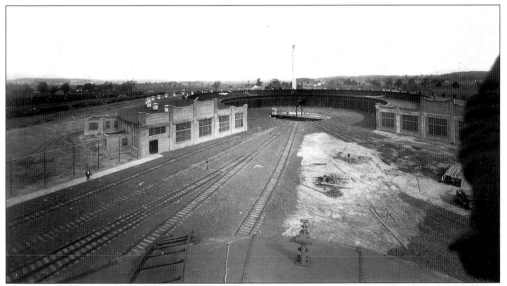

In 1924 this Grand Trunk Railroad Roundhouse, located on the south side of Emmett Street, was built to replace the outdated 1884 building. It could accommodate 45 steam engines for maintenance at one time. It was 1,500 feet around the exterior and was demolished in the early 1970s. This photo is from the late 1920s. (Courtesy of the Frances Thornton Collection.)

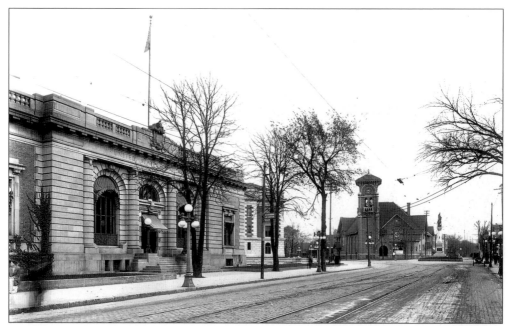

The United States Post Office on Main Street (now East Michigan Avenue) opened May 7, 1907. This photo from around 1910 shows the beaux-arts building, designed by Detroit architect Albert Kahn. The building is now known as Commerce Point. The building on the right is the First United Methodist Church. (Courtesy of the Frances Thornton Collection.)

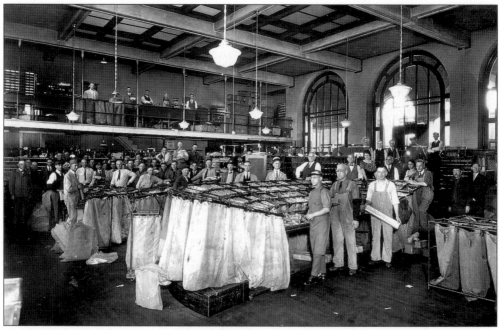

This is an image of the interior of the 1907 United States Post Office, showing the workers in the mail sorting room. The post office moved to a new location on McCamly Street in 1968. The building sat empty until 1979, when it was remodeled for the Hall of Justice, and is now called Commerce Point. (Courtesy of the Frances Thornton Collection.)

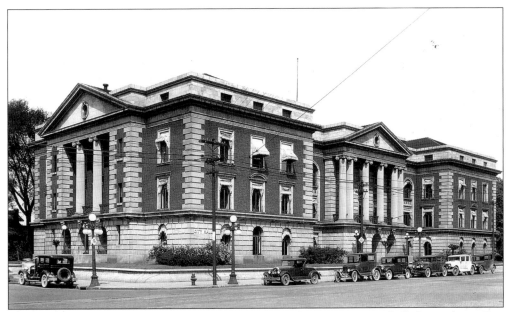

Battle Creek's city government moved to its present location on Marshall Street (now East Michigan Avenue) in 1914. The beaux-arts building, built to complement the United States Post Office across Division Street, was designed by E.W. Arnold and cost $305,000 to construct. The contractor was S.B. Cole. It housed courtrooms, offices, and, for a few years, the police department. This photo was taken in the early 1920s. (Courtesy of the Frances Thornton Collection.)

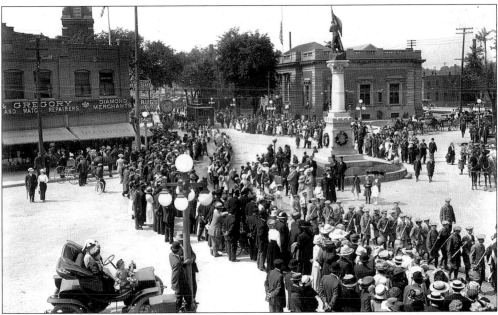

This undated photo is of a memorial parade marching through Monument Square, so named for the Soldier and Sailor Monument located at the intersection of Main Street, Marshall Street (now East Michigan Avenue), and Division Street. The monument was dedicated in 1901, and then moved to McCamly Park in 1966 to make way for a highway. The United States Post Office can be seen in the background on Main Street. (Courtesy of the Frances Thornton Collection.)

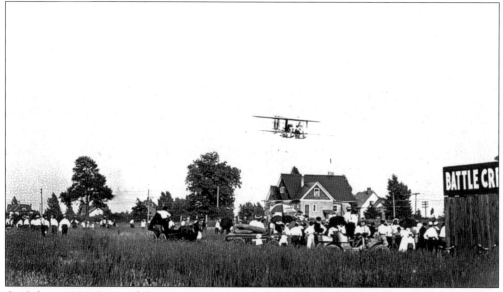

On July 4, 1911, Leonard Bonney, an associate of the Wright brothers flew their "warp wing aeroplane" at the park near Goguac Lake. The airplane arrived by train and crashed on its first flight. But after having new parts delivered from their company in Dayton, Ohio, the aeroplane flew and Battle Creek entered the "air age." (Courtesy of the Frances Thornton Collection.)

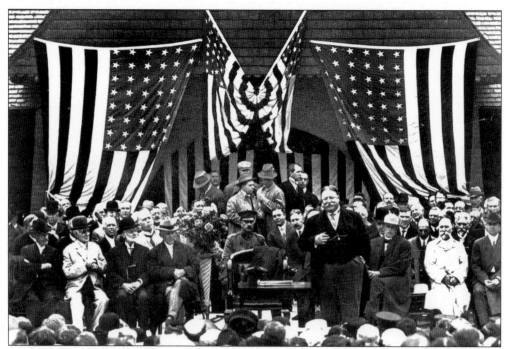

President Taft visited Battle Creek on September 21, 1911, and made a speech at the Michigan Central Train Station. Legend has it that Dr. John Harvey Kellogg (at right, dressed in his trademark all-white) disliked C.W. Post so much that he put his hat on the chair between them so that Post(seated on Kellogg's right, with a Stetson hat), could not sit next to him. (Courtesy of the Frances Thornton Collection.)

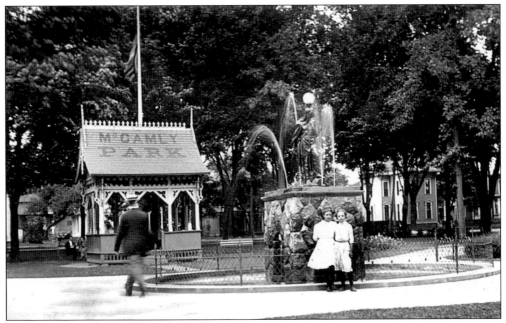

When Sands McCamly drew the original plat of Battle Creek, he set aside land for a central square. The city officially named it McCamly Park, to honor the city's founder, on May 3, 1880. The Native American statue was moved to Irving Park in 1966 to make room for the Soldier and Sailor monument. This undated postcard is from the early 1900s. (Courtesy of the Frances Thornton Collection.)

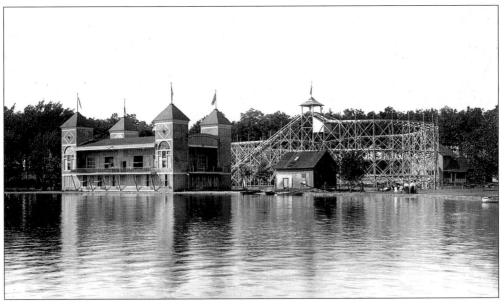

In the early 1900s an amusement park named Liberty Park was built on the north end of Goguac Lake. It had a casino/bathhouse that was purchased and then moved here from the St. Louis, Louisiana Purchase Exposition of 1904. The park had many rides (including a roller coaster built between 1918–1920) and parties in the dancehall on the casino's second floor. The park closed in 1933. This photo is from the 1920s. (Courtesy of the Frances Thornton Collection.)

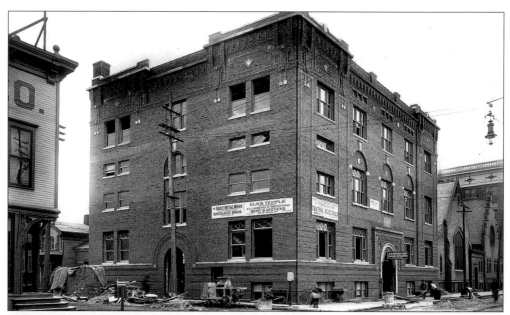

This 1911 photo shows the construction of the Italian Renaissance Elks Lodge Number 131 on the southeast corner of McCamly Street and State Street. The red brick and Bedford limestone structure was designed by Milwaukee architect Henry C. Hengels at a cost of $65,000. The building was torn down in 1987. (Courtesy of the Frances Thornton Collection.)

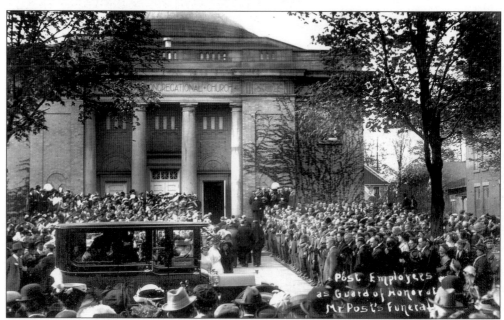

After a lifetime of poor health, C.W. Post committed suicide May 9, 1914, in his home in Santa Barbara, California. His funeral was held at the Congregational Church on Capital Avenue Northeast, shown in this photo. After a procession through town, he was interred in his family mausoleum at Oak Hill Cemetery. His daughter Marjorie Post inherited the bulk of his fortune and together with her husband, E.F. Hutton, helped create the General Foods Corporation. (Courtesy of the Frances Thornton Collection.)

In 1915 the City Bank Building was constructed on the southwest corner of Michigan Avenue and Capital Avenue as shown in this photo. The eight-story building replaced the Noble Block and was designed by Chicago architecture firm Jackson-Casse Engineers. (Courtesy of the Historical Society of Battle Creek.)

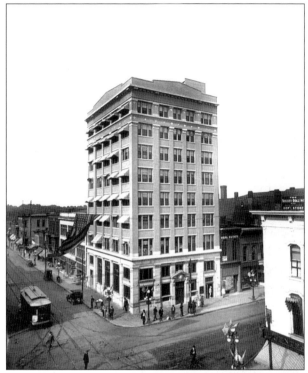

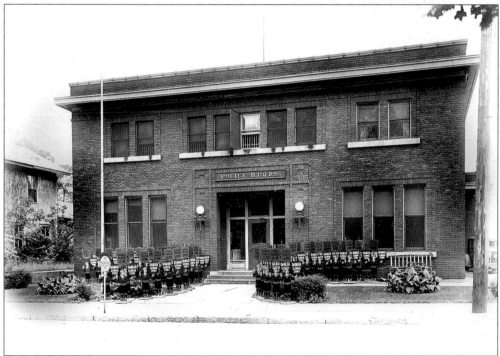

From 1916 until 1971, this building housed the offices and jail for the Battle Creek Police Department. It was located on the northeast corner of Division Street and State Street (now Patterson Street), as shown in this 1920s photo. (Courtesy of the Frances Thornton Collection.)

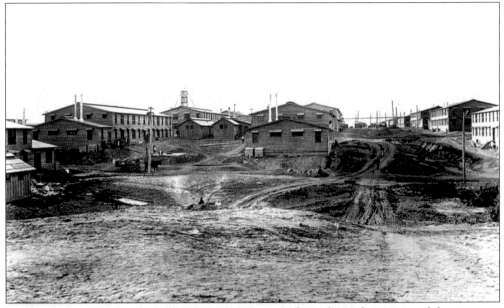

Between July and December of 1917, 8,000 men transformed 100 farms west of the city into Camp Custer, one of 36 cantonments built nationwide to prepare soldiers for World War I. The 8,000-acre camp was named after Brigadier General George A. Custer. At its peak, it held more than 60,000 soldiers. This photo shows the barracks under construction. (Courtesy of the Frances Thornton Collection.)

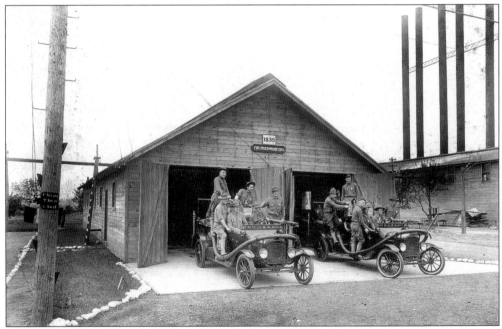

Camp Custer was formally dedicated on October 23, 1918. The camp was a complete, self-sufficient city with its own water supply, sewer system, central heating plant, hospital, bakery, laundry, theaters, library, facilities to train horses and mules, and fire department, pictured here. (Courtesy of the Frances Thornton Collection.)

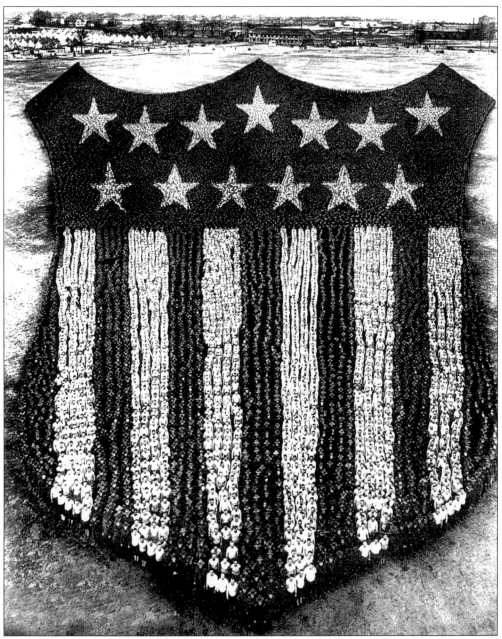

By building a camera tower tall enough and making 30,000 soldiers, dressed in three different color uniforms, stand in pre-marked areas, they were able to form this "Human United States Shield" in 1918. The camp can be seen in the distance. (Courtesy of the Frances Thornton Collection.)

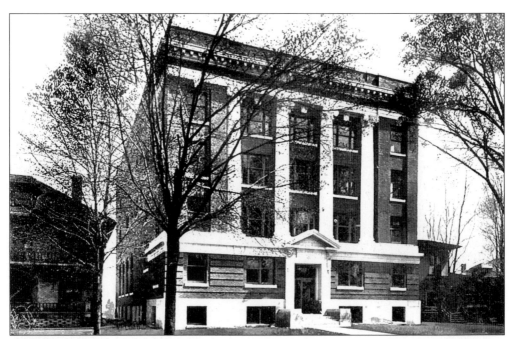

The Grand Rapids firm of Osgood and Osgood designed the Masonic Temple on East Michigan. This undated postcard shows the five-story Wadsworth brick and white terra-cotta building. It was dedicated in 1914 and cost $85,000. It is located where Jonathon Guernsey built the first log cabin in Battle Creek. (Courtesy of the Frances Thornton Collection.)

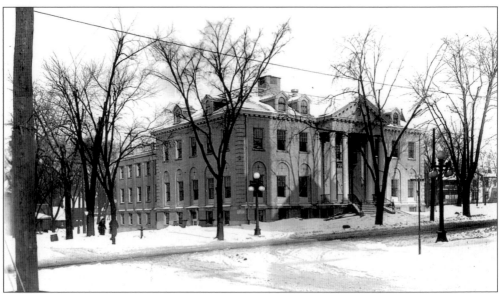

Irving Stone (president of the Duplex Printing Company) donated the money for the construction of this yellow brick neoclassical YWCA on the northwest corner of Capital Avenue Northeast and Van Buren Street. The building was designed by C.D. McLane and included meeting rooms, a swimming pool, and a gymnasium/auditorium that could seat 700 people, as well as housing for single women on the third floor, because when Camp Custer opened, rooms to rent were scarce. This photo was taken in the 1920s. (Courtesy of the Frances Thornton Collection.)

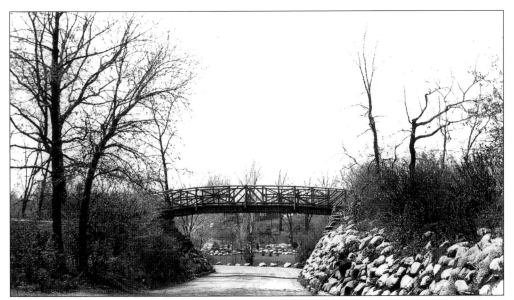

This rustic bridge over a one-lane Emmett Street was located behind Community Hospital and part of the vast Irving Park that was dedicated in 1924. The park was a gift to the city from Irving Stone and included streams, ponds, a 400-year-old white oak, and rock gardens developed from a swampy area on the city's north side. Landscape architect T. Clifton Shepherd designed this park and the Leila Arboretum. (Courtesy of the E.W. Roberts Collection.)

In 1922, Leila Post Montgomery (C.W. Post's widow) donated the 72-acre former Battle Creek Country Club on West Michigan Avenue to the city for development into an arboretum. The plan was to plant at least one of every type tree that can thrive in Michigan soil. In 1931 local architect A.B. Chanel designed the Kingman Museum of Natural History (shown in this 1930s photo) as part of the park. It was the first museum in the United States owned and operated by a public school system. (Courtesy of the E.W. Roberts Collection.)

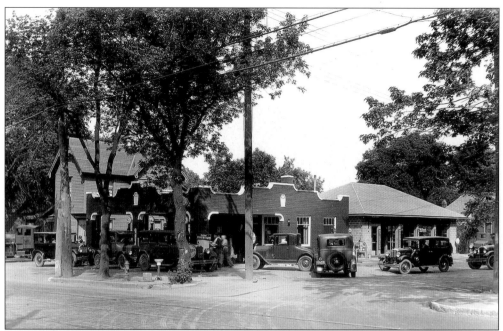

Battle Creek's first gas station was a Standard Oil station, opened December 27, 1918. Later, this full service station located on the northeast corner of Capital Avenue S.W. and Burnham Street was built in 1929. Howard Taylor, son of the station's owner, Charles Taylor, designed the building. (Courtesy of the Martin Ashley Collection.)

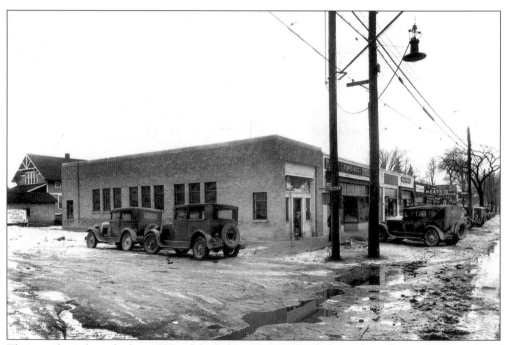

This is a photo from the late 1920s of the Lakeview State Bank, located on the southeast corner of Capital Avenue Southwest and Territorial Road. The bank opened December 21, 1926, and later merged with the Security Bank on August 1, 1950. (Courtesy of the Frances Thornton Collection.)

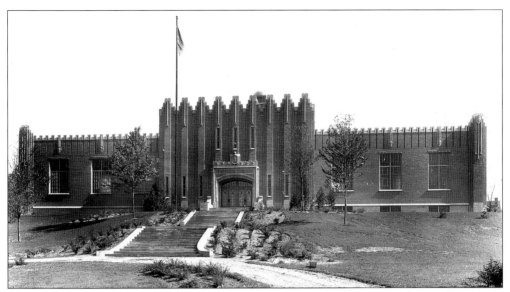

On June 14, 1928, the Associated Boys Club dedicated this building on Mykins Hill in Irving Park. The structure was donated by W.K. Kellogg and was designed by the Grand Rapids architects Benjamin and Benjamin. It contained a swimming pool, gymnasiums, a dining room, meeting rooms, and a band room. and was donated to the city in 1950 for its recreation department. It was remodeled and made into 39 apartments in 2003, and is now known as the Village at Irving Park. (Courtesy of the Frances Thornton Collection.)

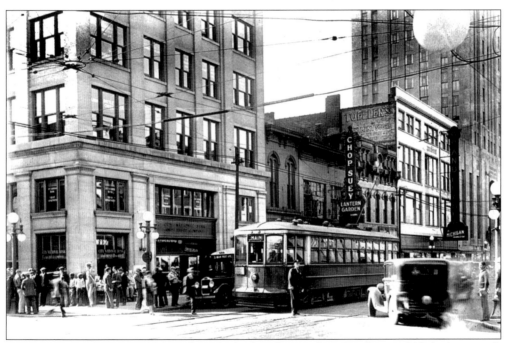

In 1891, the city's streetcars were electrified. This photo, taken October 1, 1932, looks towards the southwest corner of Michigan Avenue and Capital Avenue on the last day of trolley car service in Battle Creek. One of the new city buses can be seen next to the streetcar. (Courtesy of the Historical Society of Battle Creek.)

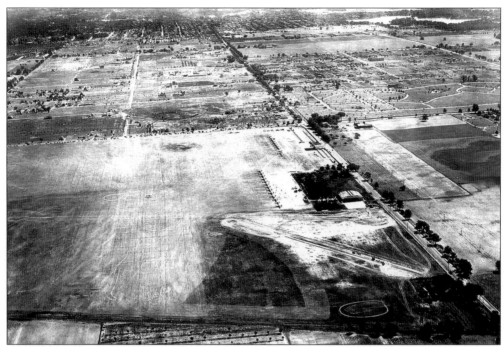

On September 24, 1924, the Battle Creek Chamber of Commerce convinced the city to lease Garret Wells farm and create an airport. In 1928 W.K. Kellogg bought the original 100 acres and leased 50 more. In 1936, through the W.K. Kellogg Foundation, it was donated to the city. This photo from August 22, 1936, is looking east and shows the United States Army Air Corps flying training maneuvers. Memorial Park Cemetery on Territorial Road can be seen on the right, with Goguac Lake on the upper right and downtown in the distance.

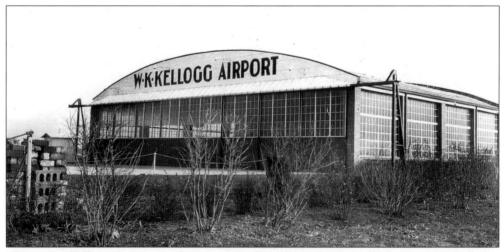

This is the Kellogg Hanger on Territorial Road c. 1937. A story told by Dr. J.H. Kellogg's personal secretary was that one of his friends was W.K. Kellogg's chauffeur and an airplane promoter. Supposedly, W.K. wasn't sure that air service was worth the money, so whenever W.K. wanted to drive out to the airport to check his investment, the chauffeur would call out to the hanger and tell them to get as many planes in the air as possible. W.K. saw how active the facility was and kept supporting it. (Courtesy of the E.W. Roberts Collection.)

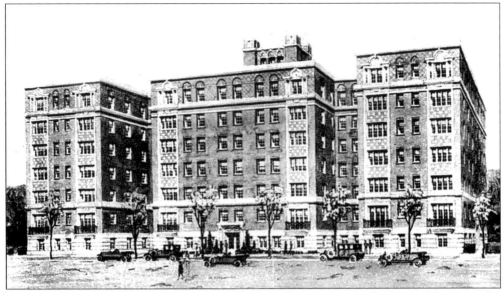

The Kellogg Inn, as shown in this postcard, was built in 1926 on Champion Street as a 72-apartment hotel, designed by M.J. Morehouse. W.K. Kellogg was superstitious, being the seventh son of a seventh son, born on the seventh day of the seventh month . . . so he moved into the seventh floor apartment of this building. The modern conveniences included a central refrigeration system and twin Murphy beds in each apartment. The Kellogg Foundation offices were located on the first floor from 1930 until 1967. (Courtesy of the Frances Thornton Collection.)

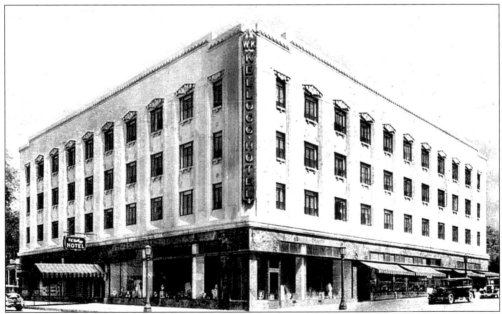

In 1930 the W. K. Kellogg Hotel opened on the northwest corner of Washington Avenue and Van Buren Street, as competition with the Post Tavern. This undated postcard shows the Indiana limestone Art Deco building that was designed by M.J. Morehouse. The lobby featured a black marble fireplace. In 1938 Thomas Hart purchased the structure and renamed it the Hart Hotel. (Courtesy of the Frances Thornton Collection.)

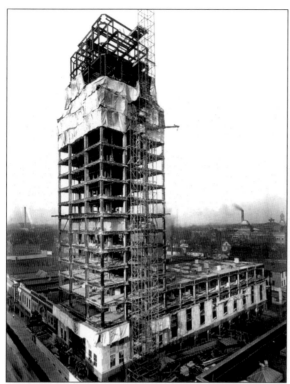

In 1931 the Central National Bank built this 18-story office building on the northwest corner of McCamly Street and West Michigan Avenue, shown here under construction and designed by Chicago architects Holabird and Root. The exterior is clad in Indiana limestone and there is a bronze panel over the front entrance depicting "Progress of Community." There is an underground parking lot and a penthouse called the "Sky Larks Nest" originally occupied by the bank president, Ezra Clark, who was also a founder of the Clark Equipment Company. In 1972 it was named the Wolverine Tower, and in 1984, it became the Transamerica Building. (Courtesy of the Frances Thornton Collection.)

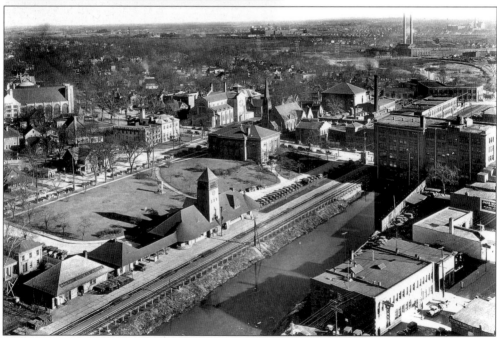

This c. 1931 photo is the view looking northeast from the top of the Central National Bank Building. The Michigan Central Train Station is in the foreground and the building to the right of St. Thomas Episcopal Church is the American Steam Pump Company, founded by Dorr Burnham. (Courtesy of the Historical Society of Battle Creek.)

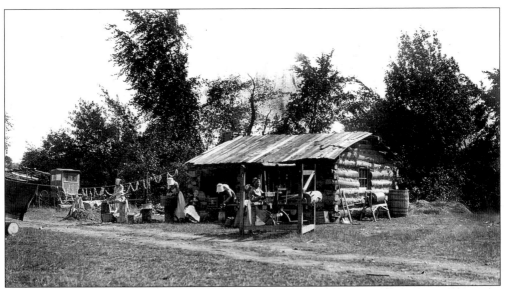

1931 saw the 100th anniversary of Battle Creek's founding. The centennial was celebrated in October with a re-enactment of the original settlers' lifestyle. A "Pioneer Village" was constructed on an area of land south of Columbia Avenue along the banks of the Kalamazoo River. That area is now a golf ball driving range. Participants lived in tents, built log cabins, milked cows, churned butter, and, as seen in this photo, used a loom for making cloth. (Courtesy of the Frances Thornton Collection.)

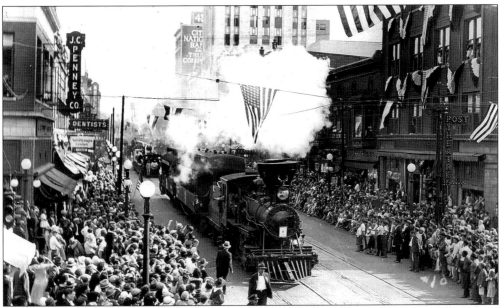

The culmination of the celebration was the "Centennial Parade" through downtown. The October 5, 1931 procession was the largest parade in the city's history. Almost all of the community's businesses participated with floats or decorated wagons, or just marched in costumes. One of the highlights was a full-size steam engine that ran on the streetcar tracks down Michigan Avenue. True to Battle Creek's history of waiting at a crossing for a train, this steam engine had to wait for a freight train to pass. (Courtesy of the Frances Thornton Collection.)

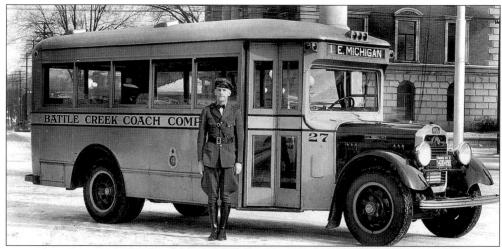

The Battle Creek Coach Company began operations on September 18, 1932. This photo shows one of the company's 18 motor coaches. The advantage over streetcars was that the buses could be routed anywhere, though it did mean the end of the city's clattering streetcars. (Courtesy of the Frances Thornton Collection.)

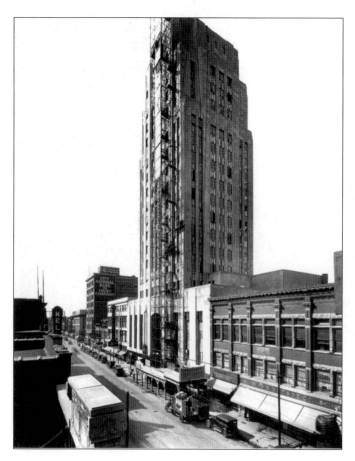

In 1930–1931, the Old Merchant National Bank built a new 20-story building on West Michigan Avenue in the center of the block on the site of the old city hall. The gray Indiana limestone structure was designed by the Chicago firm of Weary and Alford at a cost of $1.7 million. The firm also designed the Kalamazoo City Hall. (Courtesy of the Historical Society of Battle Creek.)

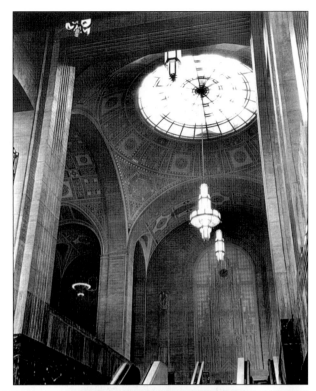

The interior of the Old Merchants National Bank was breathtaking. The 46-foot-high banking room was decorated with four kinds of marble. Murals painted with gold leaf designed by the architects displayed different motifs symbolic of banking. Each of the three new chandeliers designed by Victor Pearlman weighed 1,200 pounds. The banking room on the second floor could be entered by a flight of stairs, elevator, or the first escalators used in a bank building in the world. The formal public opening was August 15, 1931, shown in the photo below. (Courtesy of Willard Library and the Historical Society of Battle Creek.)

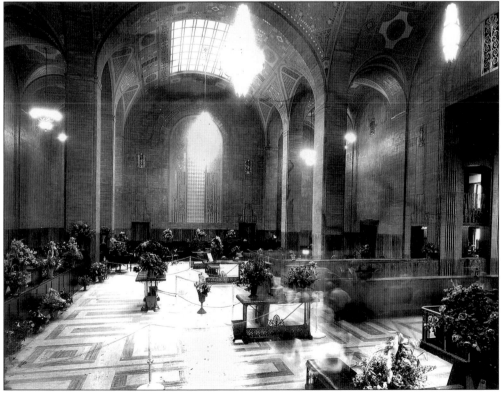

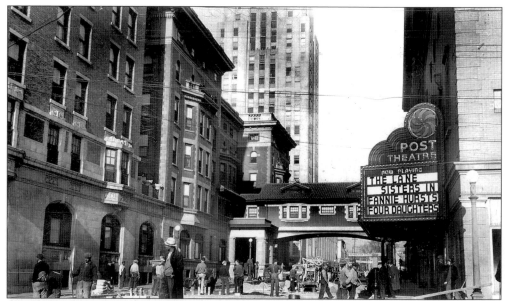

E.W. Roberts worked for 42 years at Gage Printing Company. After his retirement, he decided to combine his interest in local history with his hobby: photography. During the late 1920s and early 1930s, he created ten volumes of handwritten notebooks, combined with over 1,500 pictures recording the city's history, and called the work "Rambles with a camera around old Battle Creek." This photo, from his collection., looks north on McCamly Street in front of the Post Tavern (left) and Post Theatre (right). The workers are replacing the bricks in the street. (Courtesy of the E. W. Roberts Collection.)

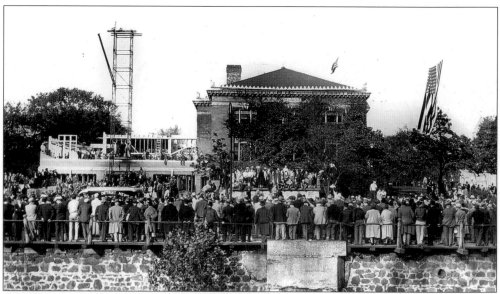

This Roberts photo, looking north across the Battle Creek River, was taken in 1935. It shows a crowd of people waiting to see a political candidate speak at the Michigan Central Station. The construction on the addition to Willard Library, designed by local architect A.B. Chanel, is seen in the background. (Courtesy of the E. W. Roberts Collection.)

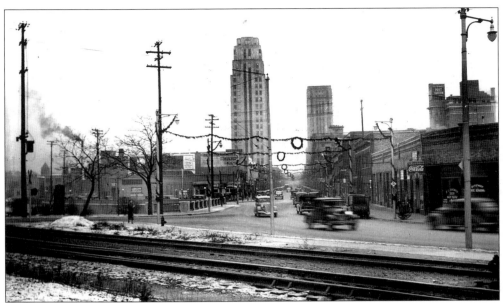

Roberts eventually donated his notebooks to the Willard Library local history collection, where they have been transcribed and indexed. While he was trying to describe something from the pioneer past, he unintentionally recorded a view of Battle Creek in the early 20th century. This photo looking east down Michigan Avenue from the front of Nichols Hospital, located on the corner of Tompkins Street, shows Battle Creek's "new" Christmas decorations. (Courtesy of the E.W. Roberts Collection.)

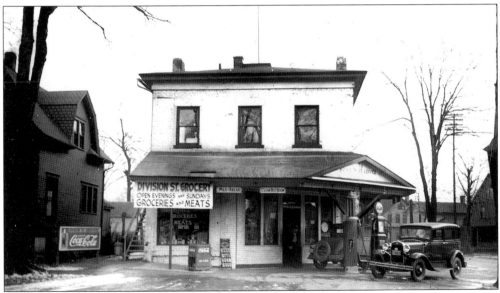

During the early 1900s, when automobile travel was new, gasoline stations were few. Many service stations were created from already standing structures. This photo from the 1930s shows a gas station on the northeast corner of Division Street and Van Buren Street. Originally built in 1867, it was once the home of Tolman Hall, a Battle Creek settler who was eventually a judge, alderman, postmaster, mayor, and state legislator. (Courtesy of the E.W. Roberts Collection.)

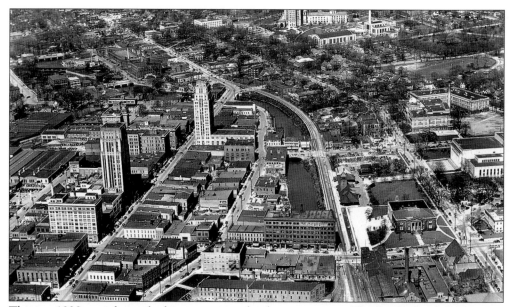

This is a 1930s aerial view looking west over the downtown area. The Battle Creek Sanitarium (now the Federal Center) can be seen in the upper center of the photo. The new W.K. Kellogg Auditorium is on the right with the astronomy dome visible on Battle Creek Central High School. In the lower center of the picture, part of the original millrace is still visible along State Street. (Courtesy of the Frances Thornton Collection.)

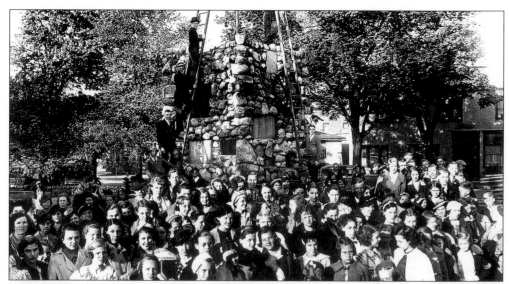

James H. Brown was the first person in the United States to organize "conducted automobile tours." While leading the tours, he would collect stones from historic sites around the country, and decided to construct a stone tower called a "cairn." In 1933 he began building this tower in Monument Park near the corner of Jackson Street and Division Street. More than just stones are included in the structure. There is a wheel from the Duplex Printing Company's first printing press, a tablet made from metal retrieved from the battleship *Maine*, an oxen yoke, a postal mailbox, a German Army helmet from World War I, and other artifacts. Brown died in 1938 before his monument could be finished. (Courtesy of the Frances Thornton Collection.)

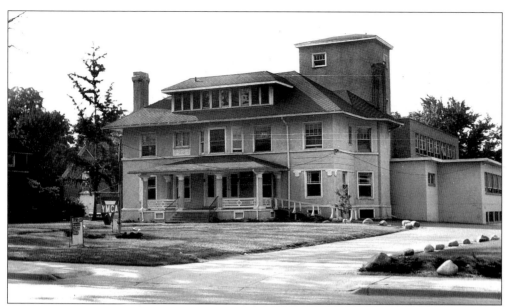

Battle Creek's first YMCA was organized in 1890. In 1902 Charles Willard donated a building on East Main (now East Michigan Avenue) to the group. It closed in 1920 due to a lack of money to maintain it. In 1940 the Maple Street Hospital was purchased and remodeled for use by the organization. This photo shows the building with the 1952 gymnasium addition. It was demolished in 1971 to make room for the new Y Center. (Courtesy of the Frances Thornton Collection.)

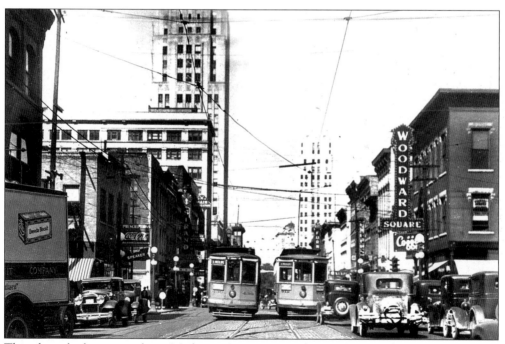

This photo looking west down Michigan Avenue was taken in front of the Battle Creek Gas Company on the left (now Ermisch Travel) showing two streetcars passing. The streetcars were eliminated in 1932, not long after this photo was taken. (Courtesy of the Historical Society of Battle Creek.)

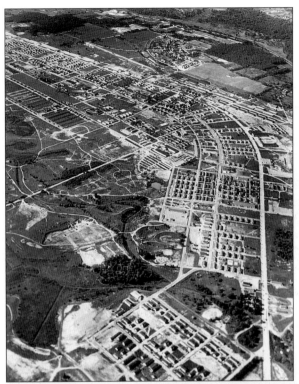

Fort Custer was re-activated on August 17, 1940, as a permanent military reservation. Another 6,000 acres were added to the facility and additional barracks were constructed. This photo from the early 1940s looks north, with Dickman Road running from the lower right up through the facility. The fort also became a processing center for prisoners of war. More than 4,000 German POWs were interred here. (Courtesy of the Frances Thornton Collection.)

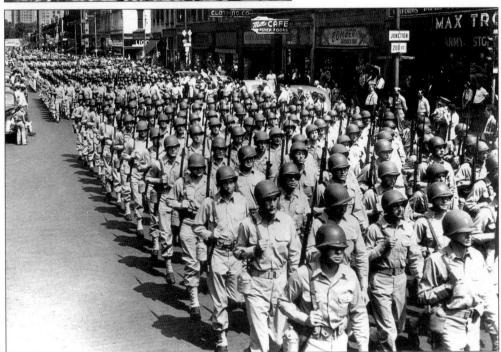

In this photo, taken on Memorial Day, 1944, some of the troops stationed at Fort Custer joined in the parade through downtown Battle Creek. This photo looks northwest on Michigan Avenue towards the intersection of Capital Avenue. (Courtesy of the Historical Society of Battle Creek.)

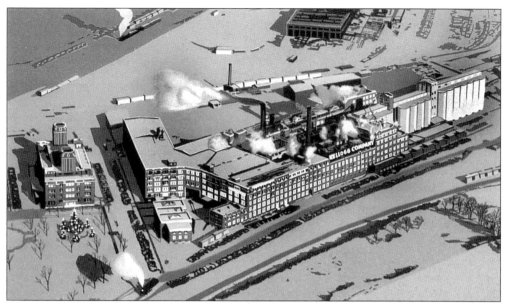

This is a 1941 Christmas card from W.K. Kellogg showing the Kellogg Company on Porter Street. (Courtesy of the Frances Thornton Collection.)

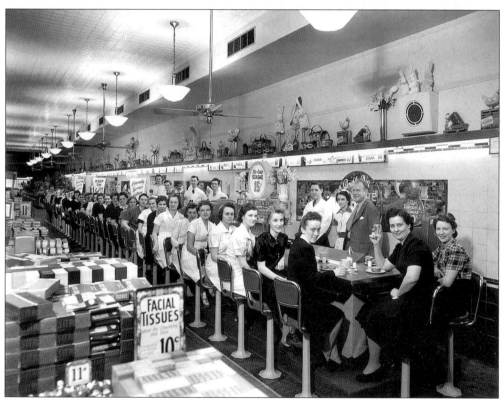

The lunch counter at Kresge's on West Michigan Avenue was a popular meeting place when this photo was taken in the 1950s. Many people remember the "friendly service" and the paper cone-cups used for soft drinks. (Courtesy of the Historical Society of Battle Creek.)

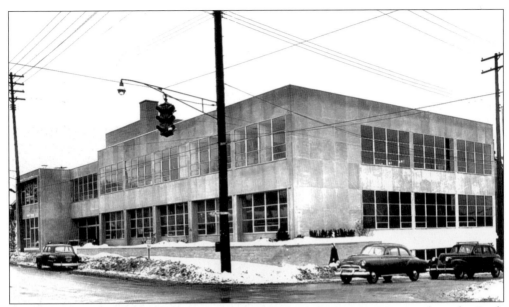

In 1918 A.L. Miller combined the *Morning Enquirer* and the *Evening News* to form the *Battle Creek Enquirer and News*. A new white Indiana limestone building was constructed on the southeast corner of Van Buren Street and Tompkins Street in 1952, shown in this photo.

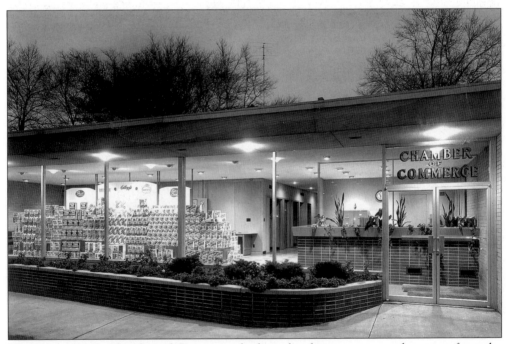

The Battle Creek Chamber of Commerce built its headquarters across the street from the *Enquirer and News* on the northwest corner of Van Buren Street and Tompkins in 1954. The display in the window, shown in this photo taken in the late 1950s, highlights the different cereals produced in city's factories. (Courtesy of the Frances Thornton Collection.)

In 1956, to celebrate the 50th anniversary of the Kellogg Company, the city held the Cereal City Festival. As part of the festivities, the assistant editor of the *Battle Creek Enquirer and News*, Gerald A. Smith, conceived the idea of Longest Breakfast Table in the World. By bringing picnic tables and benches from all of the city parks and lining them end-to-end on Michigan Avenue, volunteers were able to serve 15,000 people. This photo looks northwest on West Michigan Avenue from the First Baptist Church.

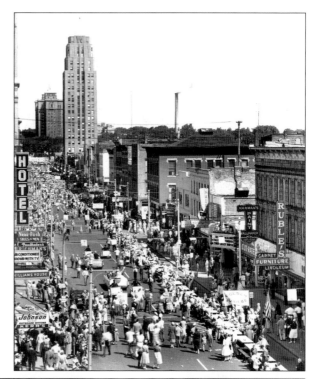

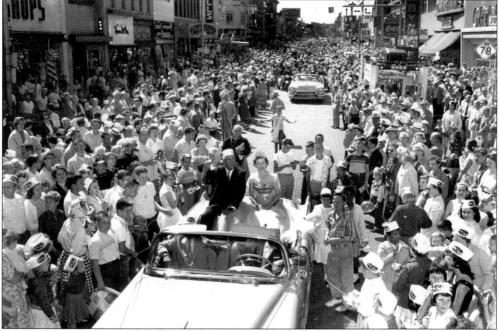

As part of the cereal festival, many people dressed in antique costumes from the early 1900s. There was also a "Sweetheart of the Corn" contest, an acknowledgement to the Kellogg Company's first large advertising campaign promoting the best corn being used for cornflakes. In this photo the "Sweetheart" is Anita Miller, being escorted to the breakfast table by the Company's president, W.H. Vanderploeg.

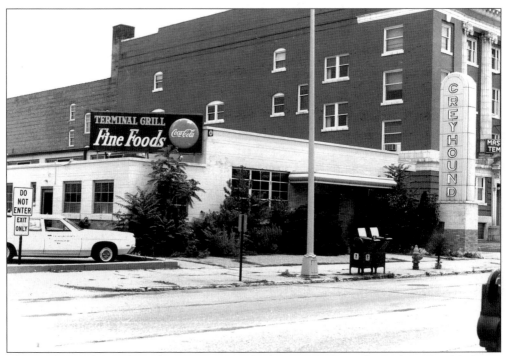

The Battle Creek Greyhound Bus station was built in 1949. It was located on East Michigan Avenue between the City Hall and the Masonic Temple and contained a large waiting room and small restaurant called the "Terminal Grill." It was demolished in the 1970s and a new station was built off Division Street near St.Philip's "Tiger Room." This photo is from the 1970s. (Courtesy of the City of Battle Creek.)

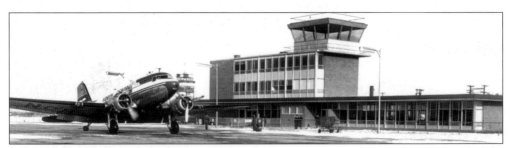

After World War II, the Kellogg Airfield was returned to civilian use. The 172nd Fighter Squadron of the Michigan National Guard established a base on the northwest side of the airport in 1947. The airport was certified a "class five" field, capable of handling the largest land-based aircraft. In 1955, North Central Airlines began providing regularly scheduled service, and a new terminal and administration building were opened in 1958, shown here.

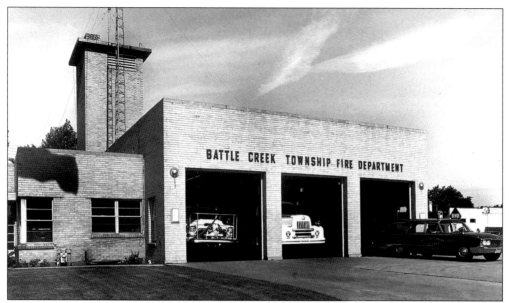

When soldiers began returning to civilian life after World War II ended, many looked to purchase homes in the suburbs. Battle Creek Township grew the fastest of the separate governmental units. To protect the homes and businesses, the municipalities began providing regular fire service. This fire station is located on 20th Street near Territorial Road, photographed in the 1960s. (Courtesy of the Frances Thornton Collection.)

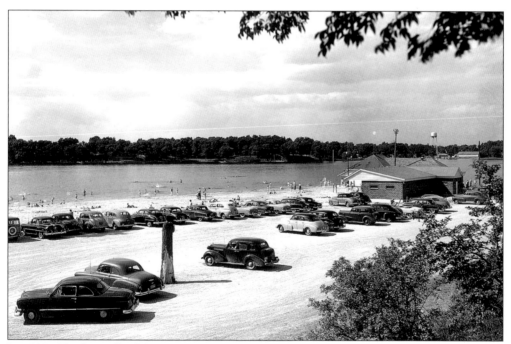

In 1897, Charles Willard donated 16 acres of land on Goguac Lake to the city to be maintained as a public park. After World War II ended, the city developed Willard Beach. When this photo was taken in late 1950s, cars were able to park within a short walking distance of the bathhouse/concession stand and the sandy beach. (Courtesy of Willard Library.)

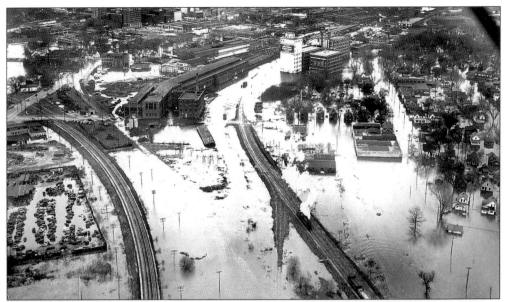

Because of its location between two rivers, Battle Creek had been plagued with floods throughout its history, some very severe. In March of 1947, one of the worst floods covered much of downtown and the low-lying area south of the central businesses known as the "flats." This aerial view of that flood looks east from Kendall Street. The Duplex Printing Company and Ralston Purina factories are in the center of the photo. (Courtesy of the Martin Ashley Collection.)

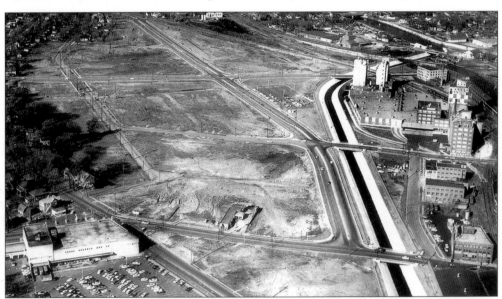

In 1954, Congress passed the Omnibus Flood Control Act. Four million dollars in federal funds were allocated for the Kalamazoo River channel diversion, while $3 million of local funding was made available for land acquisition. The river channel was finished in 1962. This aerial photo from that time looks northwest from over the millpond. The residential area known as the "flats" (in the center) was totally demolished as part of "urban renewal." The Sears Store (now Horrock's), on Capital Avenue Southwest and Fountain, is on the lower left, and Ralston Purina is upper right. (Courtesy of the City of Battle Creek.)

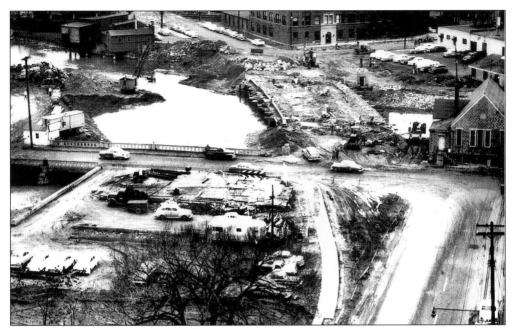

As part of the flood control project, the confluence of the Kalamazoo and Battle Creek rivers was moved west of downtown. This 1960s photo looking northwest from the Post Tavern depicts the damming of the Kalamazoo River (on the left) and the construction of a Jackson Street bridge. The Sherman Manufacturing factory, on the upper right, is now the location of Kellogg's Cereal City USA. (Courtesy of the City of Battle Creek.)

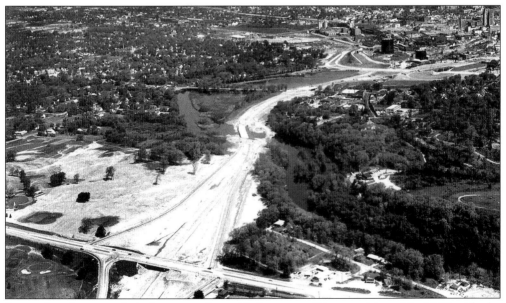

Improving the central city's connection with Interstate 94 was achieved in 1966 with the construction of the I-94 Penetrator at a cost of $4 million. The highway follows a north-south valley created by the last ice age. This early 1960s photo looks north towards the city from over Columbia Avenue. The Riverside Country Club is on the lower left. (Courtesy of the City of Battle Creek.)

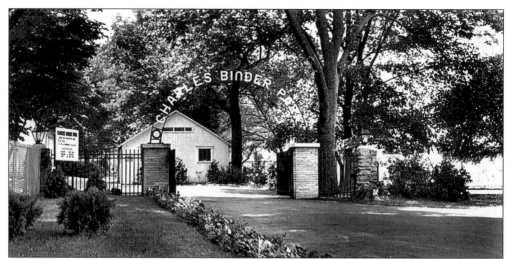

On January 2, 1958, Charles Binder Park opened south of town on land donated by Binder's wife, Cecilia, in his memory. Binder was a local meat merchant who had purchased the land because he enjoyed riding horses in the country. The park is 656 acres, which includes a golf course, picnic areas, and, since the 1970s, the Binder Park Zoo. (Courtesy of the Frances Thornton Collection.)

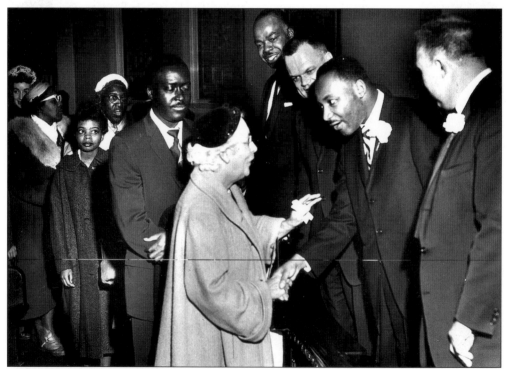

As part of the First Methodist Church's Lenten program in March of 1960, the Reverend Martin Luther King Jr. spoke at the evening service. The church was filled to capacity, extra chairs and speakers were set up in the basement. This is a photo of ministers Rev. Paul Bigby, Rev. David Evans, Rev. King, and Rev. Sidney Short greeting the audience after the program. (Courtesy of the Frances Thornton Collection.)

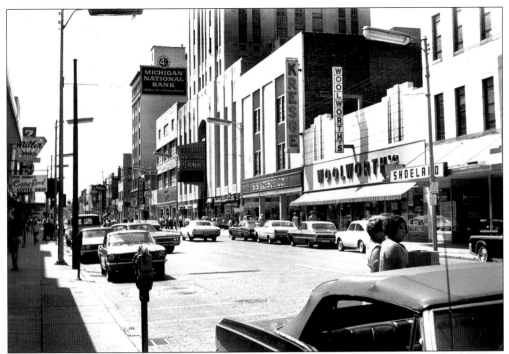

This photo taken in the mid-1960s looks east at the south side of Michigan Avenue from in front of J.C. Penney's Department Store. (Courtesy of the City of Battle Creek.)

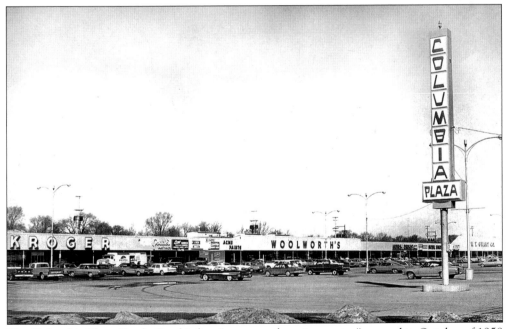

The Columbia Plaza, Battle Creek's first "one-stop shopping center" opened in October of 1958 with a weeklong celebration. The plaza was located on the west side of 20th Street between Columbia Avenue and Territorial Road, and contained 15 individual stores. This photo is from the 1960s. (Courtesy of the Historical Society of Battle Creek.)

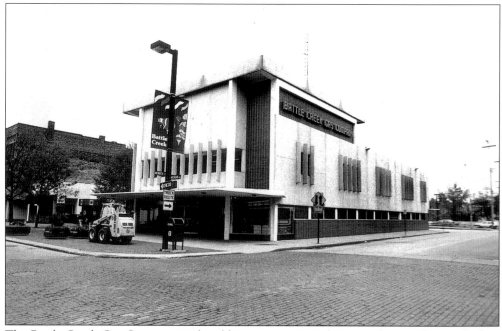

The Battle Creek Gas Company is the oldest continuous industry in the city, having had its start in 1870. This building, located on East Michigan, was opened in 1965. It was constructed over the site of the original Sands McCamly millrace and used the stone millrace walls for its basement garage and offices. This photo is from the 1970s. It was demolished in 1989.

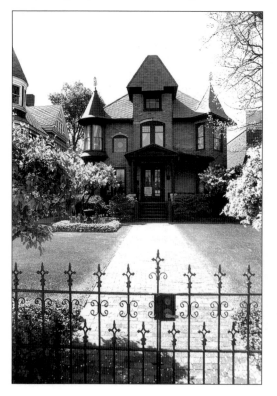

In 1886, Dr. Arthur Kimball built this Queen Anne style home on Maple Street (now Capital Avenue Northeast). Dr. Kimball helped establish the Tuberculosis Hospital in Kimball Pines and worked with Dr. John Harvey Kellogg to create "open air schools" for the city's children. After his death, the house was donated by the family and renovated over two years by the Junior League to be used as the headquarters for the Historical Society of Battle Creek. In 1966, it was donated to the historical society, and is known as the Kimball House Museum.

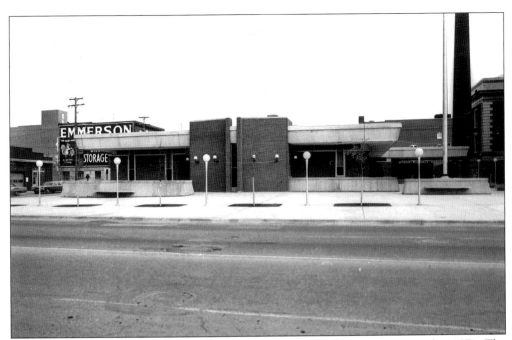

This Battle Creek Police Station at 20 North Division Street became operational in 1971. The building encompasses 32,200 square feet on two floors and cost $1.48 million. Along with office space and a communication center, it houses a firing range and parking garage in the basement. This photo is from March 1972. (Courtesy of the City of Battle Creek.)

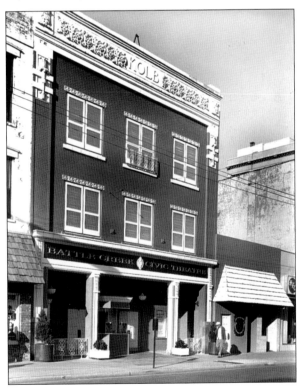

In 1946 the Battle Creek Civic Theatre began performing, at first in an empty hanger converted into an auditorium at Kellogg Airfield, and later wherever a facility was available. In February of 1973, after two years of renovation, the old Strand Movie Theater on East Michigan Avenue was reopened as the Battle Creek Civic Theatre. It was demolished in 1989. (Courtesy of the Historical Society of Battle Creek.)

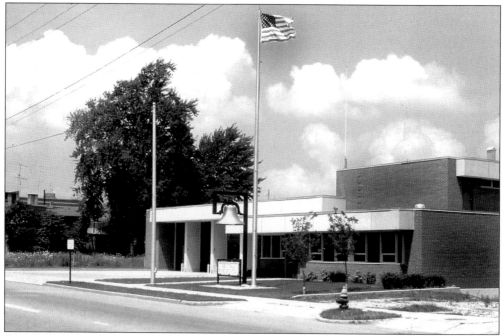

Fire Station Number One moved to this building on East Michigan Avenue in 1972. The corner stone and fire bell from the old Number One Station on Jackson Street are displayed in front of this building. This photo dates to the 1980s. (Courtesy of the City of Battle Creek.)

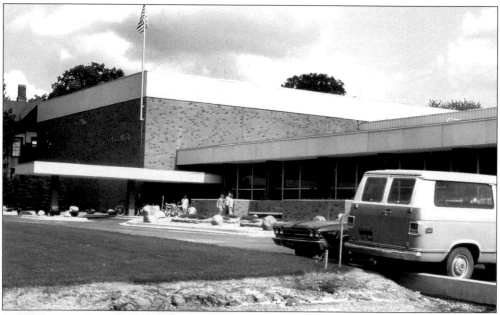

In the late 1960s, it was decided that the old YMCA on Capital Avenue Northeast was inadequate to fill the needs of the community. After a $2.7 million fund raising drive, headed by James McQuiston, construction began. The combined YMCA/YWCA facility was opened in July of 1973 as the Battle Creek Y Center. This photo was taken in the 1980s. (Courtesy of the City of Battle Creek.)

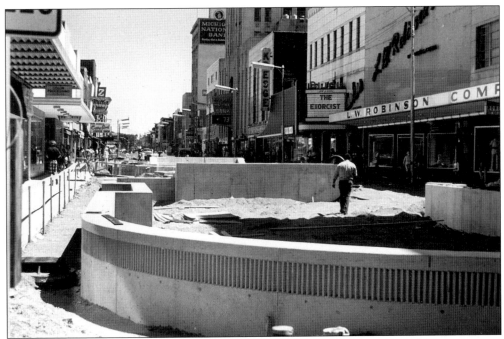

A pedestrian mall had been suggested for Battle Creek in the 1950s, but it couldn't gain support. Kermit Krum, a downtown businessman, was instrumental in rallying the public and city government to back the project. After a large donation from the Albert L. and Louise B. Miller Foundation, groundbreaking took place in 1973. This photo shows mall construction looking east down Michigan Avenue from McCamly Street. (Courtesy of the Frances Thornton Collection.)

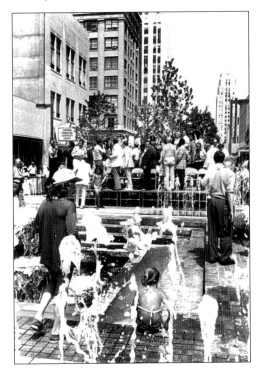

On June 27, 1975, the $2 million Michigan Mall was dedicated. The ceremony took place in front of the Battle Creek Civic Theatre. Mayor Frederick Brydges said, "We are dedicating the mall to the free spirit of the people and to the future bright with promise." When Michigan's Junior Miss, Pam Miller, cut the dedication ribbon, the fountains began flowing and the crowd turned to see fireworks over the city.

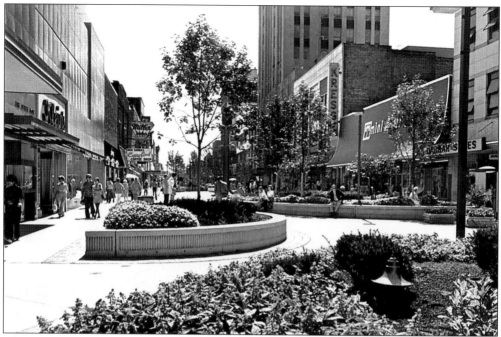

This postcard of the Michigan Mall from the 1970s looks east from near the corner of McCamly Street. To compare the change in downtown, see the picture of Michigan Avenue on page 67. (Courtesy of the Frances Thornton Collection.)

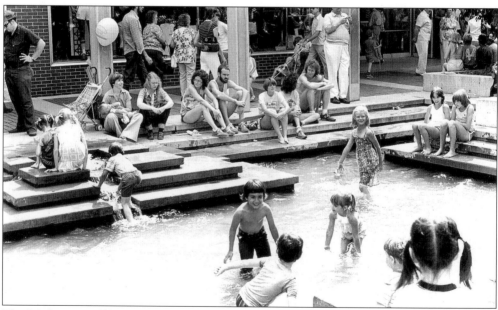

The Michigan Mall became a center for civic events. Ethnic festivals, Christmas decorations with Santa's House, band concerts, and more were scheduled to bring people downtown for some fun. The children in this photo from the 1970s have found a different way to enjoy the fountain located in front of Penny's Department Store.

The former Woolworth's store on Michigan Avenue was converted from a single retail building into the Mini Mall. The facility housed multiple small businesses including a pet store, florist shop, and sandwich shop. It was demolished in the 1980s. (Courtesy of the Frances Thornton Collection.)

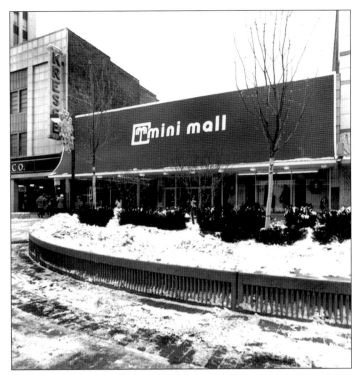

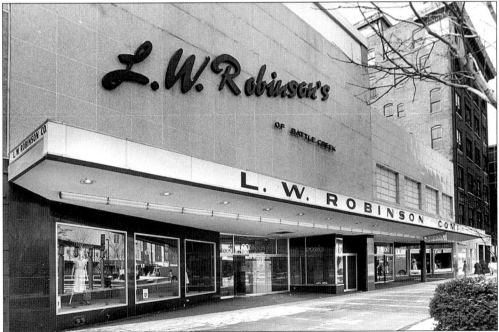

The L.W. Robinson store started as a dry goods store in October of 1888. It was located in the Post Building for many years, and moved to this building on West Michigan Avenue on February 22, 1951. It was eventually purchased by Herp's Department Store and closed in 1982. The building now houses Western Michigan University's Battle Creek Campus. This photo is from the 1970s. (Courtesy of the Frances Thornton Collection.)

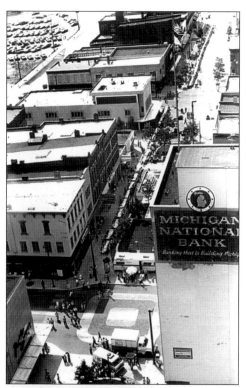

In 1976, the nation celebrated its 200th birthday. Part of the celebration in Battle Creek was the re-introduction of the Longest Breakfast Table in the World, which had originated in 1956 for the Kellogg Golden Jubilee. This 1976 photo is taken from the Security Bank Building (now Heritage Tower) looking northeast down Michigan Avenue.

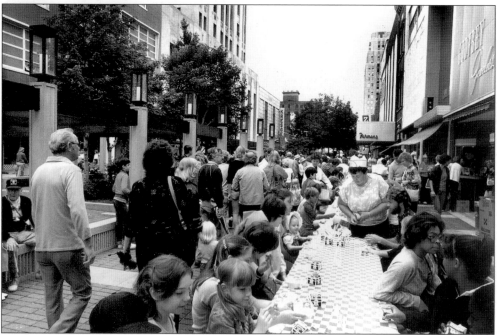

In 1976 the Battle Creek Junior League sponsored the Longest Breakfast Table in the World as a bicentennial project. They arranged the volunteers and corporate sponsors and ended up feeding 10,000 people. This photo looks west down the Michigan Mall from the intersection of Capital Avenue.

This photo of the "Longest Breakfast Table in the World" was taken in 1976 from the Security Bank Building (now Heritage Tower) looking northwest. The crowd below is enjoying a concert on the stage next to the clock tower. This bicentennial event was so popular, it became a Battle Creek tradition. The Michigan Mall was removed and the street was reopened to traffic in the late 1990s.

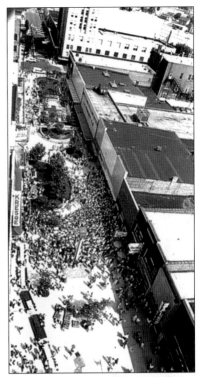

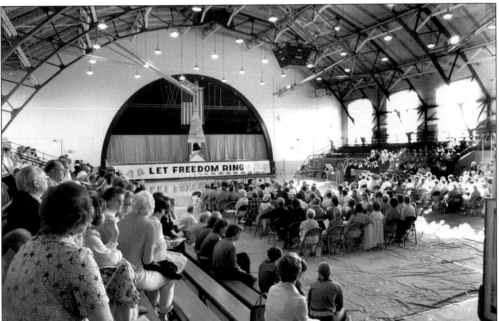

The largest ecumenical service ever held in Battle Creek took place at the Battle Creek Central Field House on July 4, 1976. As part of the bicentennial event, 1,500 people attended the program that included 20 area churches. The theme of the 90-minute service was "Let Freedom Ring" and included a 100-voice combined choir, the First Congregational Bell Ringers, speeches by civic and religious leaders, and banners created by each church.

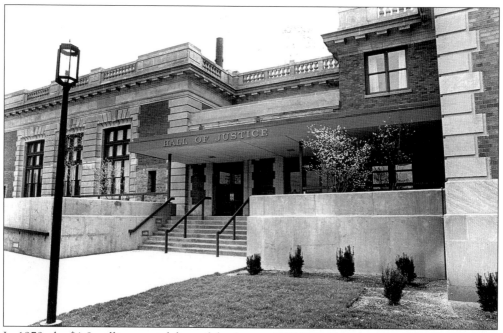

In 1979, the $1.8 million remodeling of the former 1907 United States Post Office building on Michigan Avenue into the Hall of Justice was done. The building housed the circuit and district courts and city and county offices. The new entrance to the facility was on State Street, originally the back loading dock for the post office. This photo is from 1979.

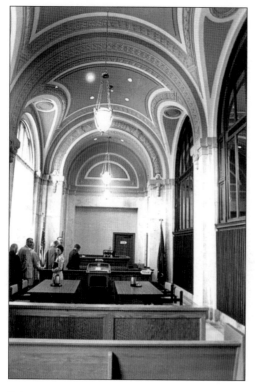

This 1979 photo shows the front lobby of the 1907 Post Office after it had been remodeled into a courtroom for the Hall of Justice. The building had a new heating plant installed and was completely air conditioned. Grants of more than $1 million were given by the U.S. Economic Development Administration, an $86,000 grant from the W.K. Kellogg Foundation, $30,000 from a Federal Historical Restoration Grant, $84,000 from a state grant through the historical division, and $44,000 allocated from the Circuit Court.

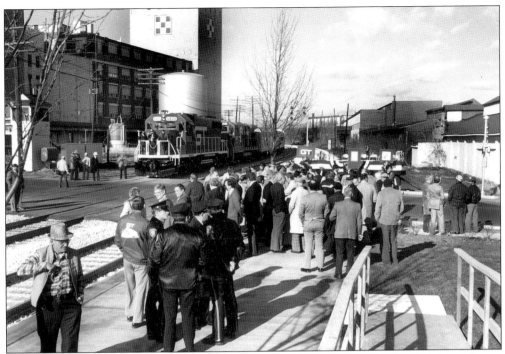

This photo was taken on November 18, 1981, at the McCamly Street railroad crossing during the ribbon-cutting ceremony acknowledging the long-awaited $14 million railroad consolidation in downtown Battle Creek. The project combined the Grand Trunk Western railroad right of way with the Conrail line, eliminating many crossings and relieving traffic congestion. Mayor Floyd Oglesby cut the ribbon using hedge cutters originally forged at the Battle Creek Grand Trunk Shops. (Courtesy of the City of Battle Creek.)

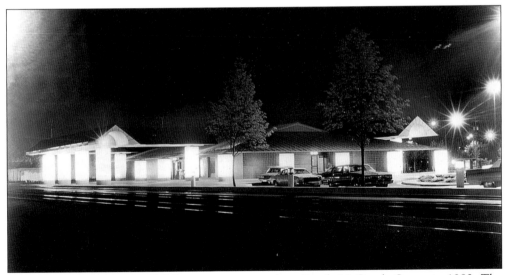

The Battle Creek Intermodal Station was opened on South McCamly Street in 1982. The post-Wright Ian train/bus/taxi terminal with horizontal gable-on-hip-roof with round, glass block columns lit from within was designed by William Kessler and Associates. This photo is from the 1980s.

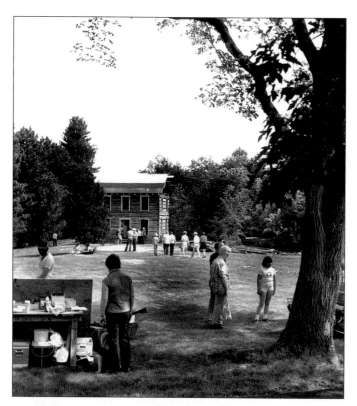

Battle Creek celebrated the 150th anniversary of its founding in 1981. Events were planned throughout the year by a Sesquicentennial Committee. The Leila Arboretum was the site for Pioneer Village, a recreation of the 1931 centennial event. An 1850s log cabin was moved by volunteers assisted by the Army Corps of Engineers from a site near Athens to an area behind the Kingman Museum. Crowds numbering 10,000 attended the 1981 Memorial Day weekend event to see blacksmiths shoe horses, broom making, quilting, weavers, and many other pioneer crafts. (Courtesy of the Frances Thornton Collection.)

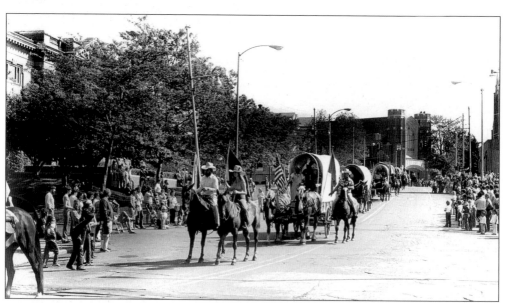

May 27, 1981, was the date of the Sesquicentennial Memorial Day Parade. It was co-sponsored by the Battle Creek United War Veteran Council and the Sesquicentennial Committee. The parade included bands, floats, and this wagon train from the Pioneer Village at Leila Arboretum. This photo looking north on Capital Avenue Northeast is from the bridge over the Battle Creek River.

The Fifth World Hot Air Balloon Championship took place at Kellogg Regional Airfield the week of June 20, 1981. Two hundred thousand people watched 75 balloons from 23 countries compete in the event sponsored by the Battle Creek Area Chamber of Commerce and the Kellogg Company.

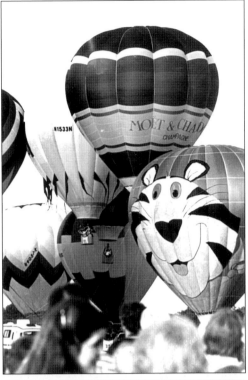

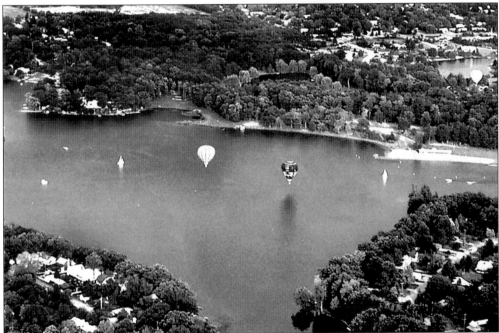

This postcard shows hot air balloons floating low over Goguac Lake. Bruce Comstock of Ann Arbor, Michigan was the Champion of the Fifth World Hot Air Balloon Championship in 1981. Since then, hot air balloon competitions have been held in Battle Creek every year. (Courtesy of the Frances Thornton Collection.)

The Battle Creek Civic Art Center was incorporated in 1948 and became a founding member of the United Arts Council in 1964, along with the Community Chorus and the Battle Creek Symphony. Also in 1964, the Christian Reformed Church on Emmett Street was donated to the art center. In 1974 and 1979, additions were constructed, enlarging the gallery space and classroom areas. This photo from 1979 shows both additions, but the roof of the old church is still visible. (Courtesy of the Battle Creek Civic Art Center.)

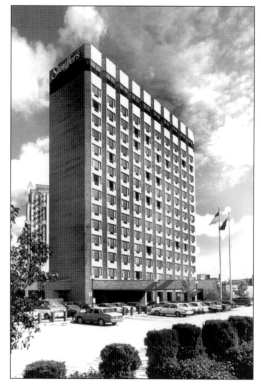

In November of 1981, the Stouffer Hotel opened on the corner of Jackson Street and Capital Avenue Southwest, featuring a 600-seat ballroom, two restaurants, and an indoor pool. The 15-story, 248-room hotel was part of the $26 million McCamly Square/Kellogg Center sports arena/exhibit hall complex. It is now called McCamly Plaza. (Courtesy of the Frances Thornton Collection.)

January 1, 1983 was the official date the City of Battle Creek and Battle Creek Township merged. The event was commemorated by burying a timecapsule under the sculpture "Circa; Gateway to the Future" located behind the Intermodal Station, shown here. The only container found to be airtight was a child's casket donated by a local funeral home. Overnight the population went from 35,729 to 56,339, and the increased area made Battle Creek the third largest city in Michigan. The sculpture and time capsule were moved to Leila Arboretum in the 1990s.

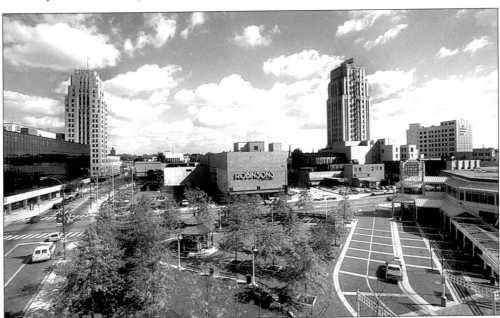

McCamly Place, a bi-level festival marketplace, opened in 1986 to complete the McCamly Square complex which included the Stouffer Hotel and Kellogg Center Arena. The facility, designed by The Collaborative Incorporated from Toledo, Ohio, included small shops, a bookstore, and many restaurants, with a central atrium with prairie style motifs. This postcard is from the 1980s and shows Festival Park, with McCamly Place at right. (Courtesy of the Frances Thornton Collection.)

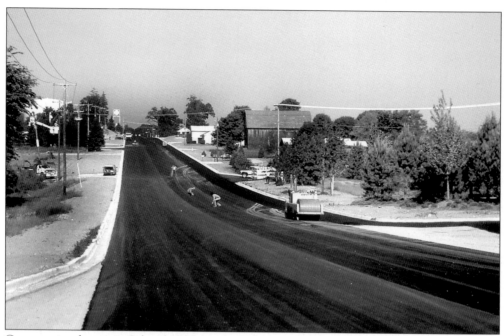

Construction began in July of 1982 on the Lakeview Square Mall on Beckley Road. It was located south of I-94 between Riverside Drive and the Penetrator (M-66). This photo from 1983 looks west from the south side of Beckley Road across from the Mall. (Courtesy of the City of Battle Creek.)

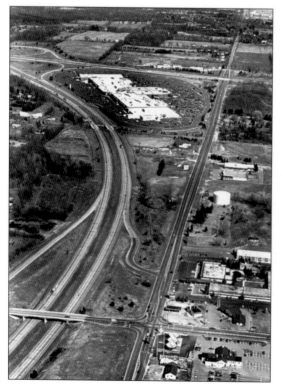

This 1983 aerial view looks east up Beckley Road from over the I-94 and Capital Avenue Southwest overpass. The 650,000-square-foot building was designed by Forbes/Cohen Development, cost $40 million, and houses 112 stores. The Lakeview Square Mall opened August 3, 1983, features sculpture by Michigan Artists, and had the first Picnic-Food Court in a mall. (Courtesy of the City of Battle Creek.)

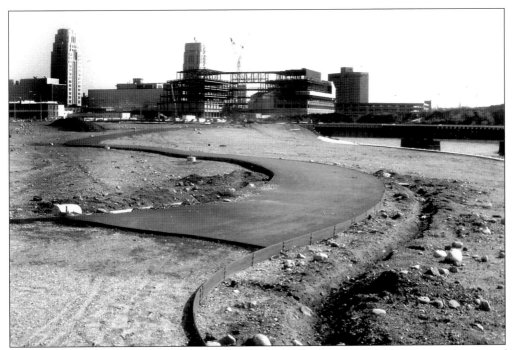

This photo taken in 1985 looks east from Washington Avenue towards the construction site of the Kellogg Company Corporate Headquarters. The Linear Park, under construction in the foreground, was opened in 1987 and encompasses 11 miles of paved paths. (Courtesy of the City of Battle Creek.)

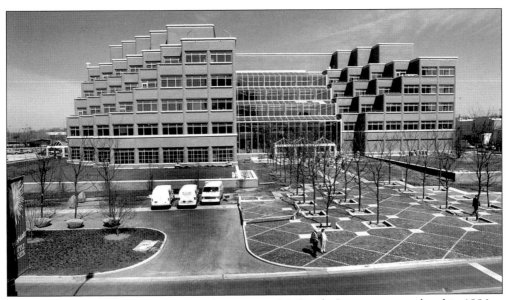

The Kellogg Company Corporate Headquarters on McCamly Street was completed in 1986 at a cost of $70 million. Hellmuth, Obata and Kassabaum designed the five-story, 300,000-square-foot facility. A grain theme is featured in etched glass, wood paneling, leaded glass sidelights, and in the oak parquet flooring. The grounds of the building are beautifully landscaped for the employees' enjoyment.

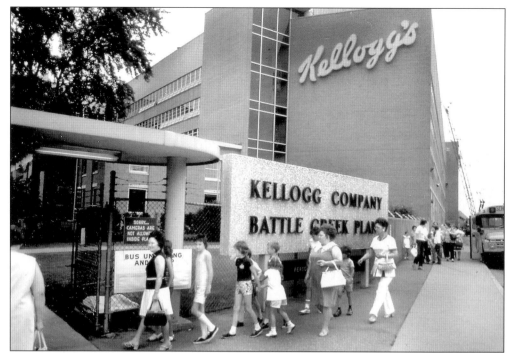

Because of corporate espionage, the Kellogg Company ended their factory tours in Battle Creek, April 11, 1986. A retired "Kellogg Tour Guide" conducted the final tour and all participants received a group photo as a souvenir. This 1980s photo shows a group of students entering the Porter Street Factory grounds. (Courtesy of the City of Battle Creek.)

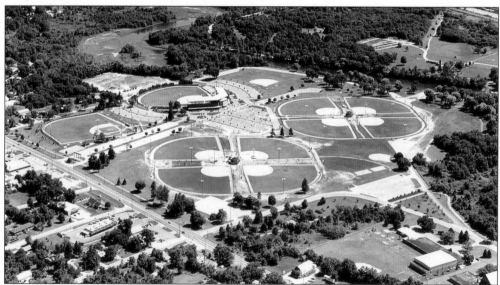

On July 4, 1990, the C.O. Brown baseball stadium was dedicated as part of the $4.1 million renovation of Bailey Park. Area foundations donated $2 million and the community raised $2.1 million. The stadium seats 6,008 and is home to the Class A professional baseball team, the Battle Creek Yankees. The other baseball diamonds were refurbished and a 12-court shuffleboard complex was added. (Courtesy of the City of Battle Creek.)

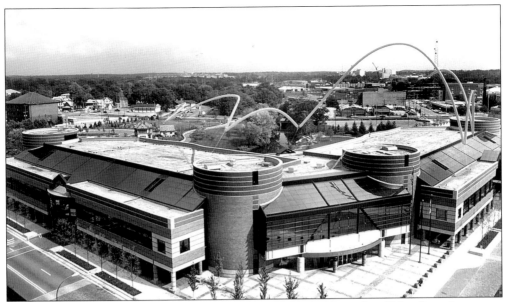

The W.K. Kellogg Foundation opened its building in 1991 as part of an $80 million downtown redevelopment. The facility is located on the northeast corner of Capital Avenue and Michigan Avenue and was designed to house a staff of 300 people. The foundation is the third largest in the United States, with assets exceeding $6 billion. W.K. Kellogg said, "I'll invest my money in people." (Courtesy of the Frances Thornton Collection.)

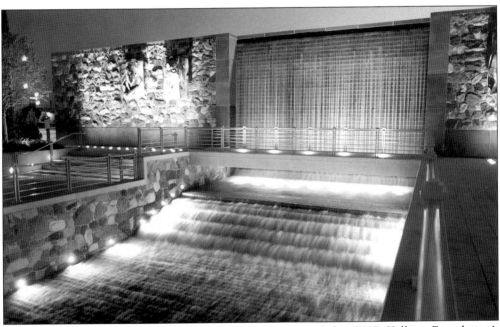

Millrace Park was dedicated August 24, 1991, as part of the W.K. Kellogg Foundation's downtown redevelopment. The park, located on the south side of Michigan Avenue across from the foundation building, commemorates the old millrace built by Sands McCamly. The waterfall runs throughout the summer and features sculptured panels by artist Tim Woodman, depicting the history of the waterway.

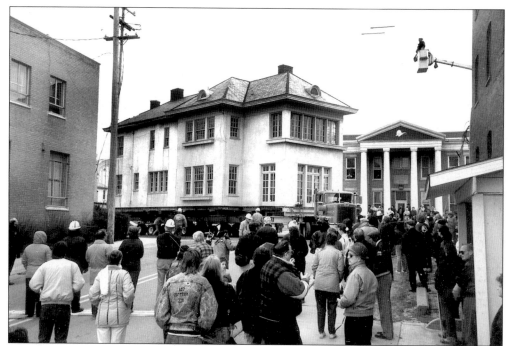

The house that W.K. Kellogg lived in from 1918 until 1924 was located at 256 West Van Buren Street. As part of the W.K. Kellogg Foundation's downtown redevelopment, the house was moved to the north side of the Battle Creek River, directly across from the foundation building, on March 24, 1990. This photo shows the house turning the corner from Van Buren Street onto Monroe Street. (Courtesy of the Frances Thornton Collection.)

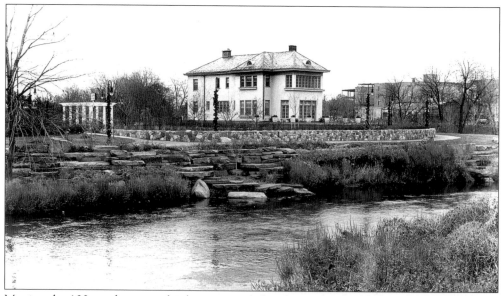

Moving the 100-ton house to this location took four hours, but building a new basement and landscaping the area took almost a year. The W.K. Kellogg House is used by the W.K. Kellogg Foundation as a base for their "expert in residence" program. This photo, taken in 1992, looks east from the Capital Avenue Bridge over the Battle Creek River.

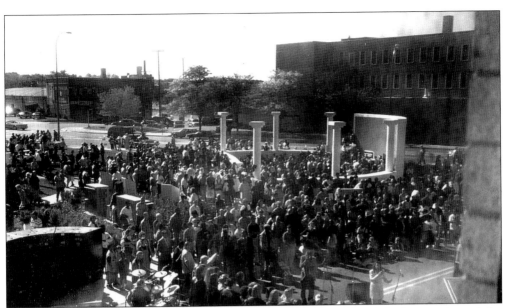

This September 1999 photo from the First United Methodist Church looks west toward the Sojourner Truth Statue dedication in Monument Park. Truth was born into slavery in 1797, named Isabella, and bought at auction in 1806. In 1826 she escaped to freedom, and spent her life speaking out against slavery and working for women's rights and other social change through peaceful methods. In 1857 she moved to Harmonia, a small town six miles west of Battle Creek, and died here in her Battle Creek home on College Street, November 26, 1883. (Courtesy of the Frances Thornton Collection.)

Tina Allen sculpted this 12-foot statue of Sojourner Truth for Monument Park in 1999. Truth moved to her home on College Street in Battle Creek in 1867. On November 2, 1877, Election Day, she shocked people (mostly men) by attempting to vote. She was turned away but continued to work for women's suffrage the rest of her life. She is buried in Oak Hill Cemetery.

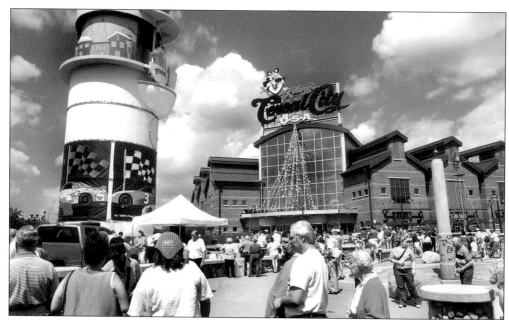

Kellogg's Cereal City U.S.A. opened in 1998 on West Michigan Avenue across the Battle CreekRiver from the Kellogg Corporate Headquarters. The building was funded partially by Kellogg Company retirees and houses exhibits that tell the story of the cereal industry here in Battle Creek through interactive displays, as well as a simulated cereal production line. This photo is of the *Battle Creek Enquirer*'s 100th birthday celebration held at the facility in 2000.

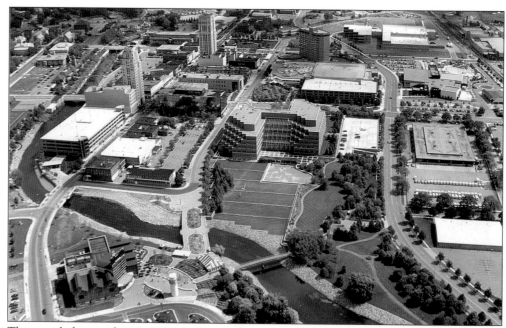

This aerial photo, taken in 2000, looks east from over Washington Avenue and shows Kellogg Cereal City U.S.A. at the lower left, the Kellogg Corporate Headquarters in the center, the Full Blast water park at center right, and the W.K. Kellogg Institute for Food and Nutrition in the upper right. (Courtesy of Harper Run Communication Arts.)

Two
EDUCATION

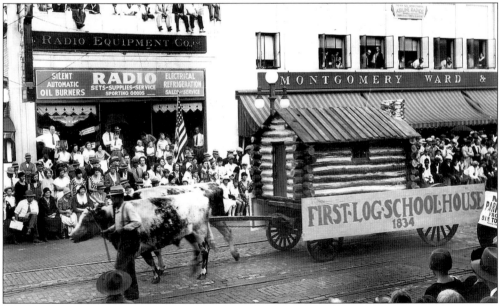

This postcard is from the 1931 Battle Creek Centennial Parade and shows the Public Schools float depicting the first log schoolhouse built in 1834. The logs for the original schoolhouse were from the surrounding woods, but the interior floors were built from planks floated down the Battle Creek River from Bellevue, because this community had no sawmill until 1835. (Courtesy of the Frances Thornton Collection.)

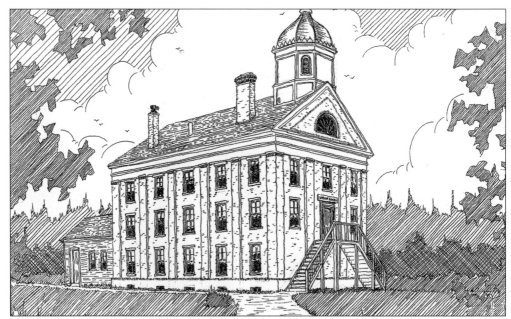

This building was the village's third schoolhouse and faced McCamly Street at the present location of the Battle Creek Central High School Music Building. It was known as "Union School" because it was the result of the united Battle Creek, Emmett, and Bedford Schools. Its construction cost was $5,500. It contained three large and three small classrooms and operated from 1847 until 1869. It was also known as "Old Capital" school. (Drawing by the author.)

Because of its growing population, the village voted on November 15, 1856 to build the "Number Two" schoolhouse on Green Street. This is the site of the old Franklin School. It is now call Stellrecht Park, named after Sam Stellrecht, the Battle Creek city planner. As the village grew, so did the number of schools: Number Three was built on Champion Street in 1861 and Number Four was built in 1866 at the corner of Jefferson (now Capital Avenue Soutwest), and Fountain Street. (Courtesy of the Frances Thornton Collection.)

"Old Number One" was built on the site of the first Union Schoolhouse and opened April 10, 1871. That same year, the state legislature voted to create the "Public Schools of Battle Creek." The building cost $75,000 and became the city's first junior high school in 1910, when the new high school was built next to it. It was demolished in 1934 after W.K. Kellogg Junior High School was opened across from it on McCamly Street. (Courtesy of the Historical Society of Battle Creek.)

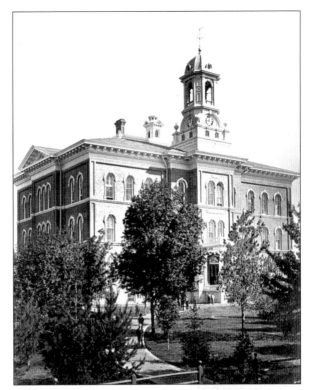

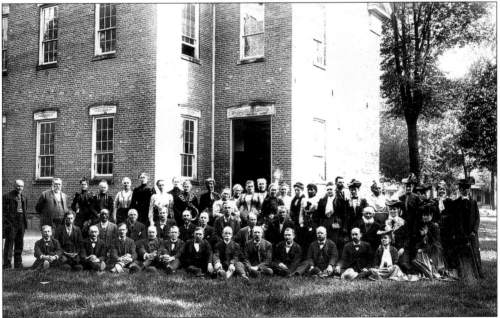

This group photo taken May 16, 1902 depicts the alumni of public school "Number Two." They met to commemorate the schoolhouse prior to its demolition to make way for Franklin Elementary School built on that site. When many of these men were young, they left this school building and went to fight in the war of rebellion now called the American Civil War. (Courtesy of the Frances Thornton Collection.)

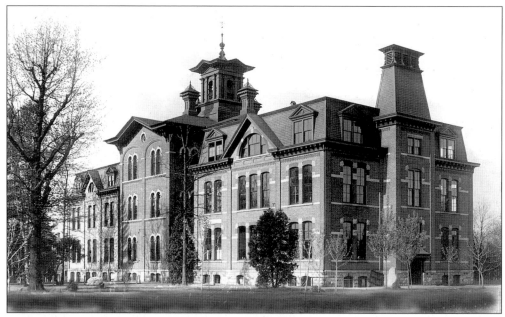

On January 4, 1875, the Seventh Day Adventists dedicated Battle Creek College, located across Washington Avenue from the Battle Creek Sanitarium. The three-story brick structure cost $30,000 and two additions were built later, a north wing in 1886 and a south in 1893. The school was renamed the American Medical Missionary College on July 3, 1895, and closed in 1910. This postcard shows the school in the early 1900s. (Courtesy of the Frances Thornton Collection.).

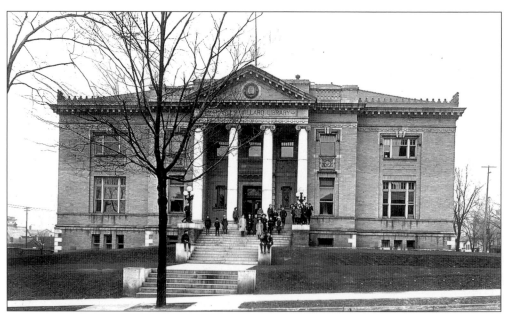

The Charles Willard Library opened April 27, 1905. The building is on the southwest corner of Capital Avenue Northeast and Van Buren Street. Beyond the four granite columns facing Capital Avenue, the lobby was decorated with white marble wainscoting and the main reading room had mahogany trim with a large skylight. The building was enlarged in 1937 and again in 1969. This photo is from the early 1900s. (Courtesy of the Frances Thornton Collection.)

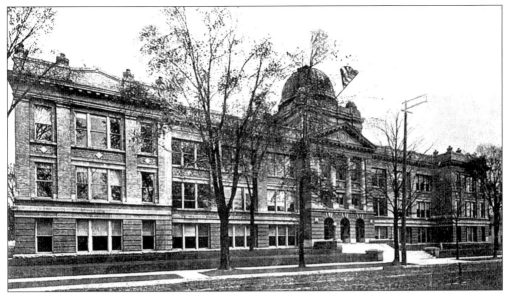

Battle Creek High School (now Battle Creek Central High School) opened this building at 100 West Van Buren Street in September 1909. Wilbur Thoburn Mills, who was also the architect of the First United Methodist Church, designed the structure. This 1909 postcard shows the school with its observation dome, which was removed during World War II. It had a three-arched central entrance that led to a wide marble staircase flanked by two large murals depicting Native American scenes. (Courtesy of the Frances Thornton Collection.)

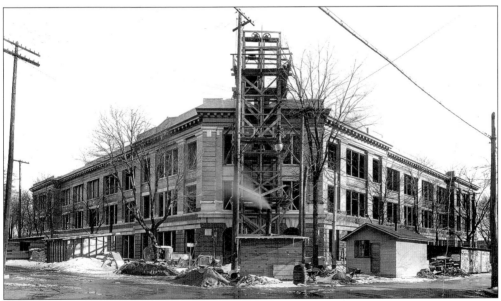

This is a photo of the Vocational Building under construction on the southeast corner of West Street and Champion Street in 1922. The $443,000 structure is part of Battle Creek Central High School and opened January 7, 1923. It was designed by J.D. Chubb and contained classrooms, industrial education rooms, a cafeteria, and a large sweeping central staircase covered with a stained glass skylight. A bridge connected it to the high school building on Van Buren Street. (Courtesy of the Frances Thornton Collection.)

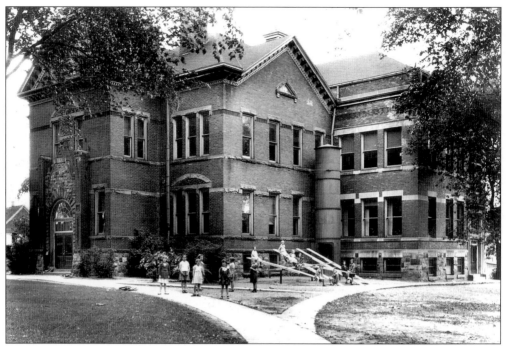

In 1889 McKinley Elementary School, originally known as "Number Five" school, was built on Capital Avenue Northeast. The building, designed by A.D. Ordway, was enlarged in 1901 and again in 1902. This photo was taken in the 1920s. (Courtesy of the Frances Thornton Collection.)

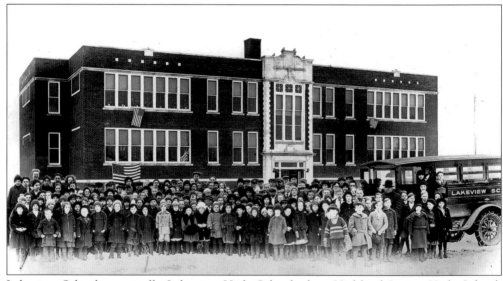

Lakeview School, eventually Lakeview High School, then Highland Junior High School, opened September 19, 1921 at a cost of $150,000. It was enlarged in 1921 and 1927. The name "Lakeview School System" was taken from the street the school was constructed on, Lakeview Avenue. This building was demolished in 1983 and a marker commemorates the school's former location on the corner of Columbia Avenue and Highland Street. (Courtesy of the Frances Thornton Collection.)

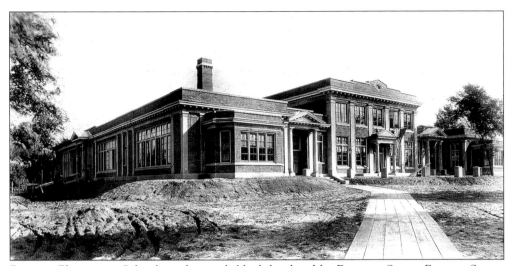

Fremont Elementary School on the north block bordered by Fremont Street, Emmett Street, and Central Street was opened in 1924. The $174,431 building, also known as "Number 14," contained 12 classrooms, an auditorium/gym, and a large kindergarten classroom on the front main floor. Doris Klaussen was the principal from 1927–1937. (Courtesy of the Historical Society of Battle Creek.)

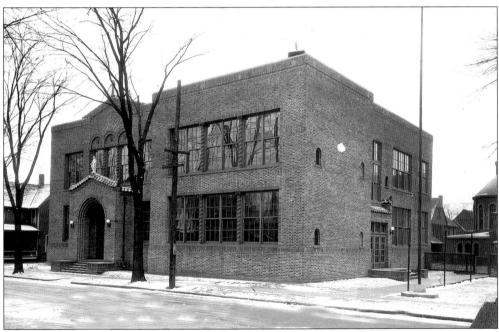

St. Phillip Catholic Parish School had its start in February of 1880. In 1924, this high school was opened on Cherry Street. Grand Rapids architect Harold L. Mead designed the building with a "unit plan"; the school could be constructed in sections as the funding became available. (Courtesy of St. Phillip Catholic Church.)

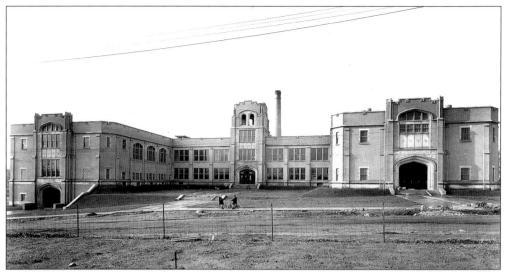

Southwestern Junior High School was opened in January of 1928 at a cost of $648,000. The building is located on Ravine Street (now South Washington Avenue) and contains a 1,200-seat auditorium, a girls' and boys' gymnasium, and 29 classrooms. The soil for the school's athletic field was fill dirt brought in from the construction site of W.K. Kellogg Junior High School. (Courtesy of the Historical Society of Battle Creek.)

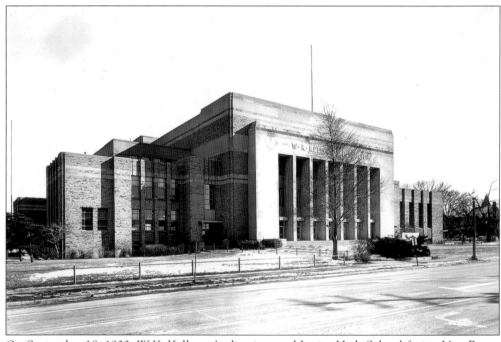

On September 18, 1933, W.K. Kellogg Auditorium and Junior High School facing Van Buren Street opened at a cost of $600,000. Mr. Kellogg wanted Battle Creek to have a civic auditorium that could draw "large delegations," plus it provided much-needed employment for area construction workers during the Great Depression. The building was designed in the International style by Detroit architect Albert Kahn with an auditorium that seated over 2,000 people. (Courtesy of the Frances Thornton Collection.)

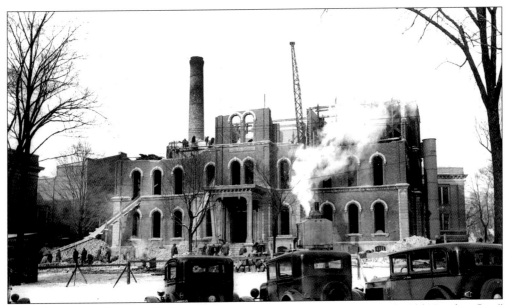

This photo looking west from McCamly Street depicts the demolition of "Old Number One" and was taken by E.W. Roberts in the early 1930s. The building had housed the original Battle Creek High School, and later became the city's first junior high. (Courtesy of the E.W. Roberts Collection.)

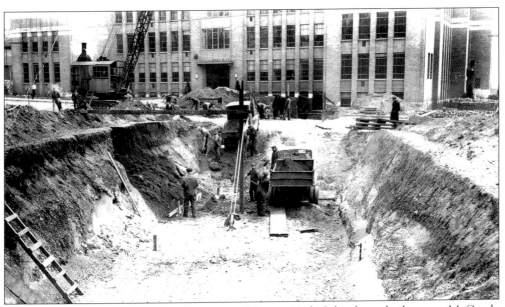

In 1933, when W.K. Kellogg Auditorium and Junior High School was built across McCamly Street from the high school, a tunnel was constructed between the two buildings. Students and faculty could remain "free from inclement weather" when passing from one to the other. In the 1980s, the McQuiston Learning Center was built over the tunnel, so it was sealed at one end and is now used for costume and set storage. (Courtesy of the E.W. Roberts Collection.)

On January 6, 1957, Springfield High School on Upton Avenue was dedicated to meet the needs of the expanding Battle Creek suburbs. Local architect Guido Binda designed the $1.2 million facility. The school was designated the Battle Creek Math and Science Center when the Springfield Public Schools merged with the Battle Creek Public Schools in the early 1980s. (Courtesy of the Willard Library.)

As Battle Creek Township grew, so did the need for a new high school. The Lakeview High School on 28th Street was opened in September of 1961. This 1,240-student capacity building was designed by architect Guido Binda and included a 1,000-seat auditorium, a 1,240-volume library, and a fallout shelter able to hold 1,200 people. (Courtesy of the Willard Library.)

C.W. Post Field, located at the northwest corner of West Street and Champion Street, was dedicated on November 3, 1961. This photo is of: Harry Davidson, the Superintendent of the Battle Creek Public Schools; George Laimbeer, the vice president of General Foods; and Marjorie Post May, the daughter of C.W. Post, standing by the entrance of the 7,000-seat stadium. May donated $250,000 to the facility, which includes three softball diamonds and seven tennis courts with parking. At the football game halftime dedication, the high school band played "Margie" for May.

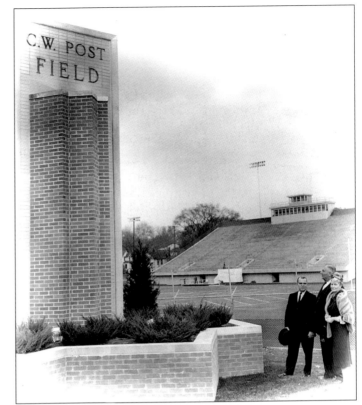

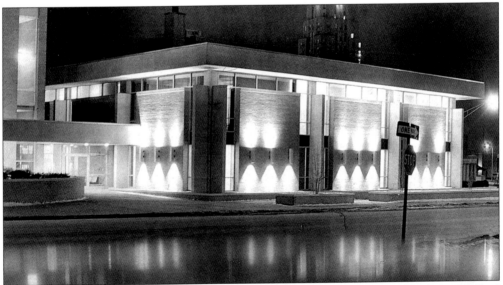

The local architecture firm Lewis Sarvis Associates designed this 1969 addition to Willard Library, which now faces Van Buren Street. The older sections of the library were remodeled to become the administrative offices of the Battle Creek Public Schools. A mural, painted on the wall of the old Children's Room by WPA artists in the 1930s, was preserved. (Courtesy of the Historical Society of Battle Creek.)

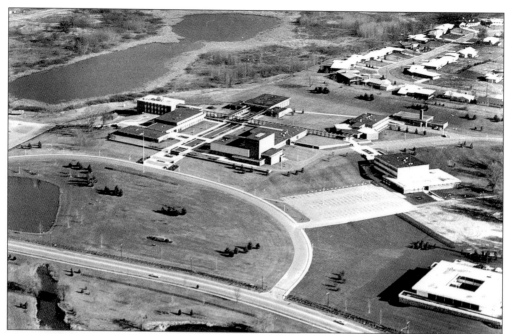

This 1965 aerial photo looks northwest from over North Avenue at Kellogg Community College, located in Kolb Park. The college originated as part of the Battle Creek Public Schools. After World War II, there was a great need for local college education. The first "Battle Creek Community College" opened in the old GAR Hall behind the high school and had an enrollment of 170 in 1956. The W.K. Kellogg Foundation contributed $2 million and the North Avenue site was dedicated in 1962. (Courtesy of the Historical Society of Battle Creek.)

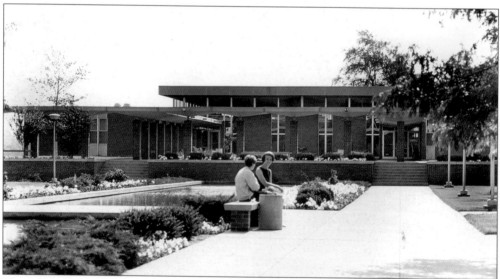

This 1960s photo looks west across the courtyard of Kellogg Community College. The building in the background is the library built in 1962. Also in 1962, the Lane Thomas Building opened, followed by the Miller Gym in 1965, the Harry R. Davidson Visual and Performing Arts Building in 1971, and the Lyle C. Roll Health and Technology Center in 1979. The campus was completely remodeled in the late 1990s. (Courtesy of the Willard Library.)

Three
HEALTH

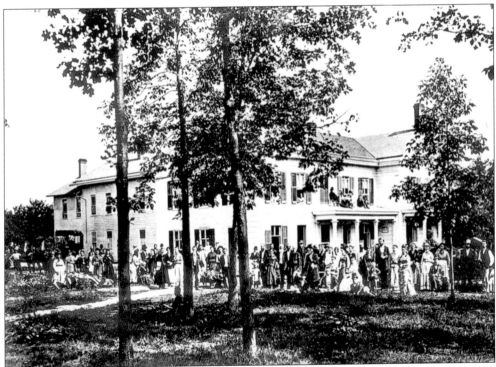

In 1866 the Seventh Day Adventists opened the Western Health Reform Institute. Dr. John Harvey Kellogg took charge of the facility in 1876. He changed the name to the Battle Creek Sanitarium because he wanted it to reflect the healthful, sanitary lifestyle he promoted. The photo is of the original building on Washington Avenue in 1876. (Courtesy of the Frances Thornton Collection.)

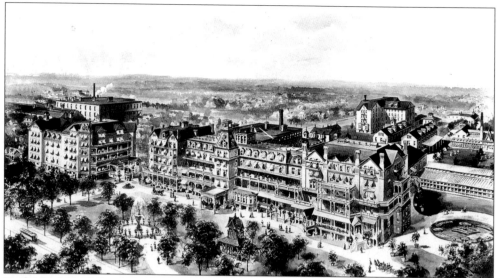

Under Dr. J.H. Kellogg's leadership, the Battle Creek Sanitarium outgrew the small white house and moved to a larger facility on the east side of Washington Avenue which opened April 10, 1878. The building was expanded in 1884, with the south addition and a north addition finished in 1891, shown in this drawing. It was in this building that Dr. Kellogg and his brother W.K. invented flaked cereal in 1898. (Courtesy of the Frances Thornton Collection.)

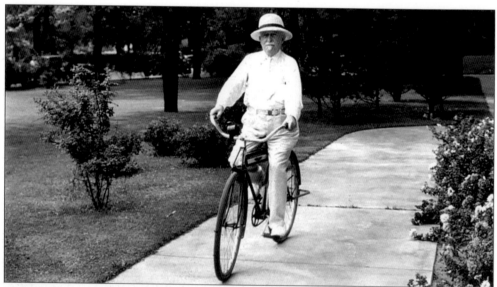

Dr. John Harvey Kellogg, the director of the Battle Creek Sanitarium, was educated at Bellevue Hospital in New York City, as well as universities in London, Berlin, Paris, and Vienna. He studied medicine with Louis Pasteur, Ivan Pavlov (yes, the one with the dogs), and Lawson Tait, considered the father of modern abdominal surgery. He wrote over 50 books, co-invented flaked cereal, as well as peanut butter, personally invented 80 different grain and nut products, and also designed surgical equipment. During his lifetime, he performed over 22,000 surgical operations without ever accepting a fee. He believed in a vegetarian diet, fresh air, plenty of exercise, and abstinence from meat, liquor, and tobacco. He is shown here riding a bike and wearing his trademark white suit. (Courtesy of the Frances Thornton Collection.)

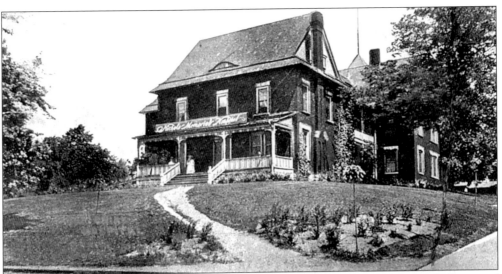

Nichols Memorial Hospital formally opened on September 17, 1890. It occupied the site of Sands McCamly's (the city's founder's) home on the corner of Tompkins Street and Main Street (now West Michigan Avenue). A $10,000 donation from the Nichols and Shepard factory founder, John C. Nichols, helped secure the property. This postcard is from the late 1890s. (Courtesy of the Frances Thornton Collection.)

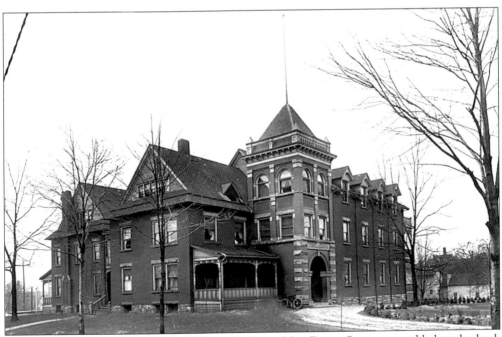

This addition to Nichols Memorial Hospital, facing Van Buren Street, was added to the back of the old building in 1901. The Nichols Memorial Training School for Nurses was constructed across Van Buren Street from the hospital to supply the much-needed medical staff for the city. (Courtesy of the Frances Thornton Collection.)

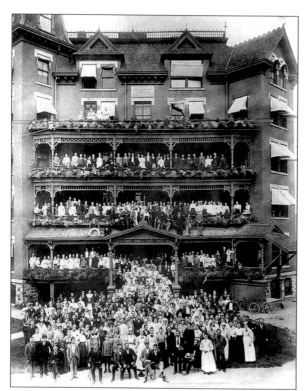

The Battle Creek Sanitarium staff pose for a group photo on the front of the Sanitarium Hospital *c.* 1900. The hospital was located north of the main building and was where surgical procedures and recovery actually took place. (Courtesy of the Joyce Stoltz Collection.)

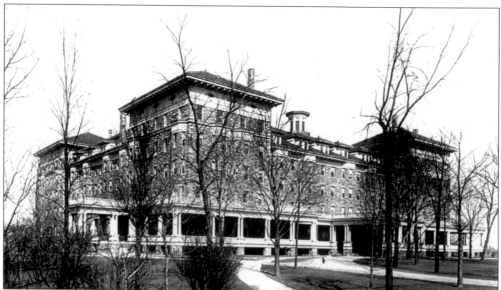

This building was built in 1901 as the Phelps Sanitorium on Washington Avenue, in competition with the Battle Creek Sanitarium located one block south. The business failed and the building was eventually acquired by the Sanitarium, in 1911, and used as an "Annex" to take care of overflow patients and to house some of the staff. When Dr. J.H. Kellogg sold the main sanitarium in 1942, he moved all operations into this building. It was the largest fieldstone building in North America when it was demolished in 1986. (Courtesy of the Frances Thornton Collection.)

On February 18, 1902, the Battle Creek Sanitarium burned to the ground. The fire could be seen for 20 miles. This view is of the central tower looking west from Washington Avenue and Sanitarium Avenue. (Courtesy of the Frances Thornton Collection.)

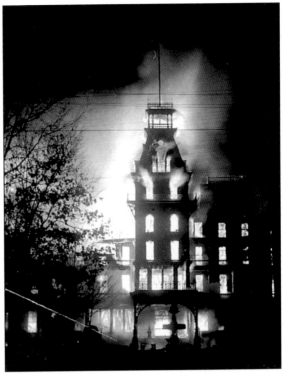

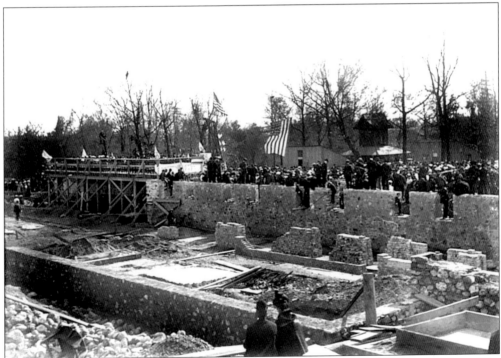

Soon after the fire, Dr. J.H. Kellogg began planning the new sanitarium building. The dedication of the cornerstone is seen in this photo taken May 11, 1902. (Courtesy of the Frances Thornton Collection.)

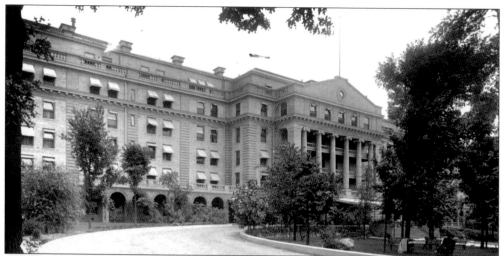

On May 31, 1903 the 550-foot-long, five-story-high Battle Creek Sanitarium was dedicated. The $1 million building, designed by the Dayton, Ohio architect Frank M. Andrews, was considered the "ideal hospital design." This photo is of the Washington Street entrance, flanked by open galleries running along the front of the building, allowing patients to receive plenty of fresh air and light, all important in Dr. J.H. Kellogg's regime of healthful living. (Courtesy of the Frances Thornton Collection.)

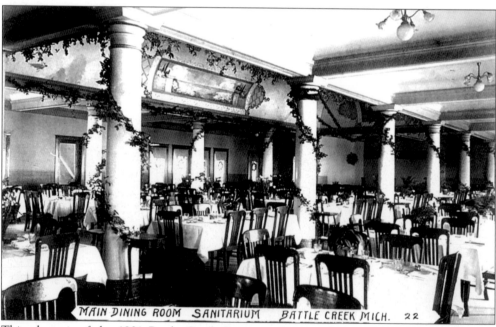

This photo is of the 1901 Battle Creek Sanitarium's main dining room. It was called the "Dining Room in the Trees" because it was located on the top floor. Dr. J.H. Kellogg believed that by having the kitchen on the roof, the cooking odors would not interfere with the patients stay. The room also gave diners a view over the countryside while they ate. Another innovation was a Palm Garden located off the main lobby. Patients could enjoy exotic plants in the glass-covered room year round; it even included a 20-foot banana tree. (Courtesy of the Frances Thornton Collection.)

In August of 1923, the United States government opened the Veterans Administration Hospital at a cost of $2 million. The 22-building complex located at the west side of Camp Custer was the largest health care facility in the state of Michigan. Orchards, a vegetable truck-farm, and a poultry and hog farm were all part of the rehabilitation programs. The V.A. Hospital now includes a 786-bed medical facility and a 205-bed nursing care unit. (Courtesy of the Frances Thornton Collection.)

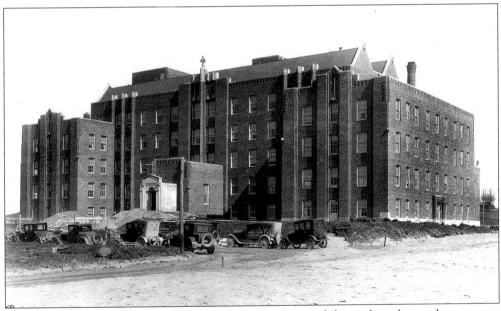

The formal dedication of Leila Y. Post Montgomery Hospital, located on the northeast corner of North Avenue and Emmett Street, was held April 19, 1927. This is a photo of the front of the 80-bed facility while still under construction. Leila Young Post Montgomery was the widow of C.W. Post. She gave the building to the Sisters of Mercy to administer after she had been a patient in a "Mercy" hospital in Detroit. (Courtesy of the Historical Society of Battle Creek.)

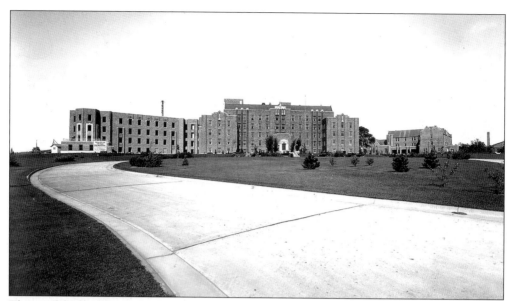

The need for health care in Battle Creek was great, so in 1929, Leila Y. Post Montgomery gave another donation for a west wing to be added, increasing the bed count to 128. The Werstein Lodge was constructed as a nursing school and was open from 1929 until 1957. It was also referred to as the "Leila Lodge" and can be seen on the right in this 1929 photo. (Courtesy of the Frances Thornton Collection.)

This photo, taken in the 1950s, shows the original lobby of the Leila Y. Post Montgomery Hospital while it was decorated for Christmas. At the top of the stairs is a statue of Jesus that remains at the present Battle Creek Health System hospital entrance. Also at the top of the stairs were the reception desk/switchboard and a waiting room.

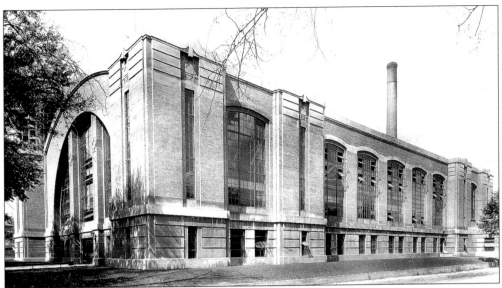

As the Battle Creek Sanitarium expanded, it added this building, the $258,000 Sanitarium Union, on the northwest corner of Champion Street and Brook Street. It was designed by M.J. Morehouse to be used by employees and for large gatherings. In 1958 it was sold to the Battle Creek Public Schools for $1 and then renovated for use by Battle Creek Central High School as the Central Field House. It contains a gymnasium that seats 5,000 people, a swimming pool, locker/shower rooms, and bowling alleys. (Courtesy of the Historical Society of Battle Creek.)

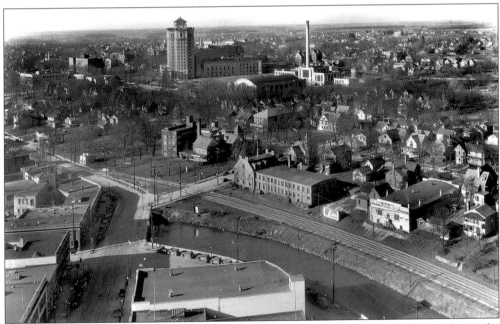

This photo was taken in the 1930s from the Central National Bank Tower (now the Transamerica Tower) looking west towards the 15-story Battle Creek Sanitarium with its power plant and Sanitarium Union Building. In the foreground next to the Battle Creek River is the fieldstone Moon Journal Building, and across Tompkins Street is the Nichols Memorial Hospital. (Courtesy of the Frances Thornton Collection.)

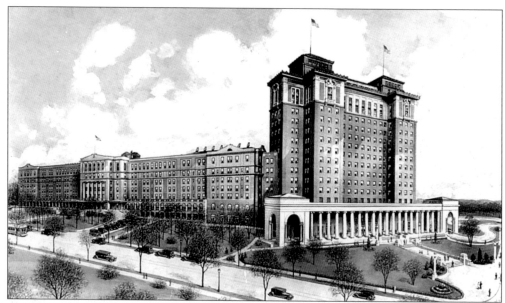

This 15-story "Towers Addition" to the Battle Creek Sanitarium was opened in 1928 and was built facing Champion Street. The $3 million building contained 265 hotel-like guest rooms, all furnished by Marshall Fields and Company. The facility had indoor/outdoor swimming pools, tennis courts, a $56,000 dairy building, the largest laundry in Michigan, its own power plant, a water pumping/softening building, and its own farms, greenhouses, orchards, and dairy farms. (Courtesy of the Frances Thornton Collection.)

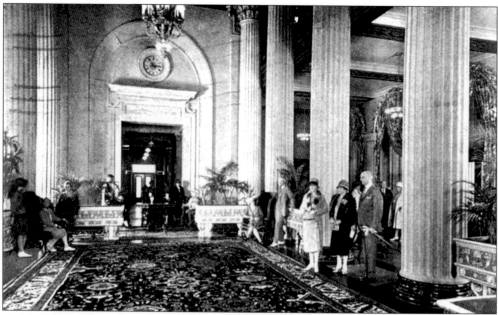

The 32-pillar colonnade at the front of the building opened into a two-story-high main lobby with 12 "Mankato" marble columns of the Battle Creek Sanitarium. Henry Ford was the first guest in the "Towers Addition" in 1928. The whole facility could now accommodate 1,250 guests and 1,800 staff. (Courtesy of the Frances Thornton Collection.)

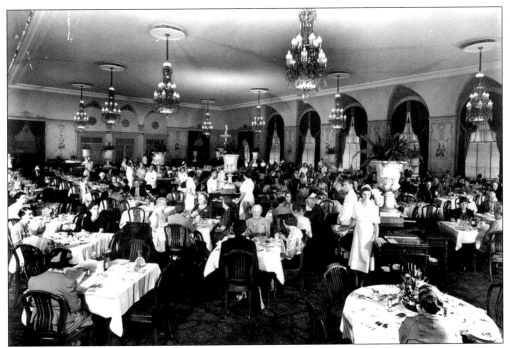

The 1928 Battle Creek Sanitarium's Main Dining Room had 10,000 square feet of space, making it the largest dining area with no visible ceiling support columns in the world. Eight Czechoslovakian lead crystal chandeliers lit the room, with 100 light bulbs in each. One thousand diners at a time could enjoy the 24 hand-painted murals on the walls. (Courtesy of the Frances Thornton Collection.)

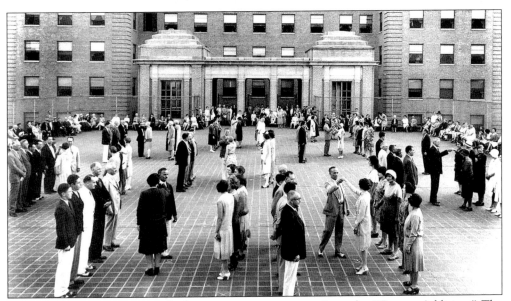

The Main Dining Room was built in a structure separate from the "Towers Addition." The dining room roof was designed so that guests could get fresh air while participating in the nightly after-dinner Grand March. Not only was it a popular social entertainment, it was exercise, as shown in this 1929 photo. (Courtesy of the Frances Thornton Collection.)

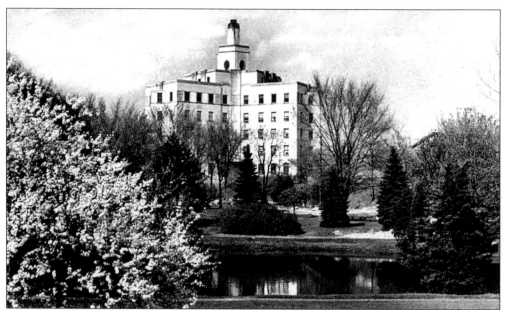

On September 12, 1938, Community Hospital opened on West Street. The hospital had formerly been the Nichols Memorial Hospital on Van Buren Street, but because of its proximity to the Michigan Central Railroad tracks, it was always noisy and smoky whenever a train passed so they moved to this site. This postcard from the early 1940s looks east from Irving Park. (Courtesy of the Frances Thornton Collection.)

This is a 1938 photo of the lobby of Community Hospital. It contained a gift shop, a cashier/switchboard, and a memorial plaque listing employees that had died at war. The lobby doors open onto Irving Park. The city of Battle Creek donated the land to the hospital.

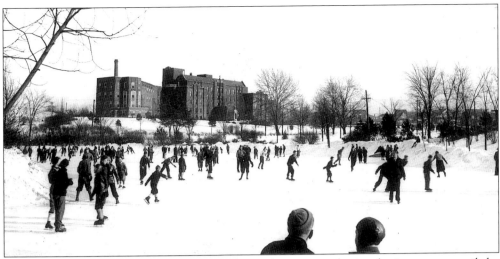

In the winter, the Irving Park Lagoon was the city's most popular ice skating venue, until the construction of the "Rink" in the mid-1980s. This photo, taken in the early 1930s, shows the frozen lagoon looking east across North Avenue at Leila Hospital. (Courtesy of the E.W. Roberts Collection.)

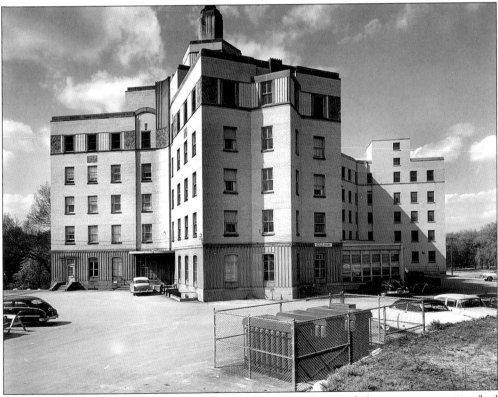

In 1959 Community Hospital added a north wing (shown at right) to increase patient/bed capacity. At the same time, the hospital opened the first Special Intensive Care unit in the state of Michigan. This photo from the late 1950s shows individual tanks of oxygen stored behind the hospital, prior to the use of large-capacity oxygen storage tanks. (Courtesy Willard Library.)

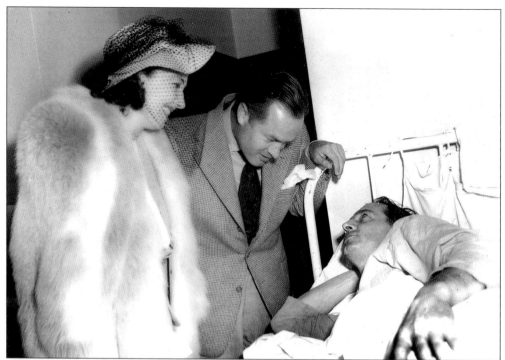

Percy Jones Army Hospital was created when the United States Army purchased the Battle Creek Sanitarium building on the northeast corner of Champion Street and Washington Avenue in 1942. The 1,500-bed hospital was used as a center for amputation, neurosurgery, and plastic surgery. During World War II and the Korean Conflict, it was the largest U.S. Army medical installation in the world. This photo from May 1947 is of Vera Vague and Bob Hope visiting a patient at the hospital as part of a USO traveling show. The facility closed in 1953 and became the Battle Creek Federal Center in 1954. (Courtesy of the Historical Society of Battle Creek.)

Lakeview General Osteopathic Hospital was originally established in a house on Elm Street. On March 3, 1957, this building opened its doors to patients at 80 North 20th Street with 56 beds on two levels and a medical staff of 28 osteopathic physicians. This photo from 1965 shows the two-story addition under construction, increasing the bed capacity to approximately 90. The hospital merged with Leila Hospital and Health Center in the 1980s and is now an extended care facility. (Courtesy of Willard Library.)

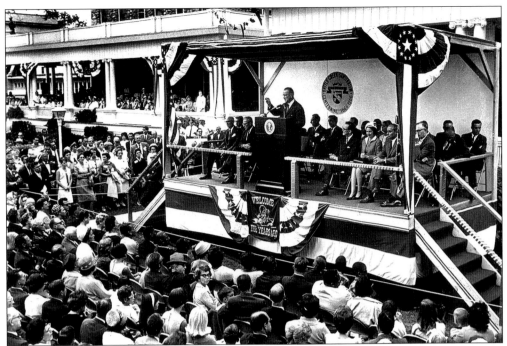

In this photo from September of 1966, President Lyndon Johnson speaks from the front porch of the fieldstone sanitarium building on Washington Avenue, commemorating the 100th anniversary of the founding of the Battle Creek Sanitarium. A crowd of more than 40,000 people gathered for the first sitting President to speak here since President Taft in 1911. The fieldstone building was demolished in 1986. (Courtesy of the Joyce Stoltz Collection.)

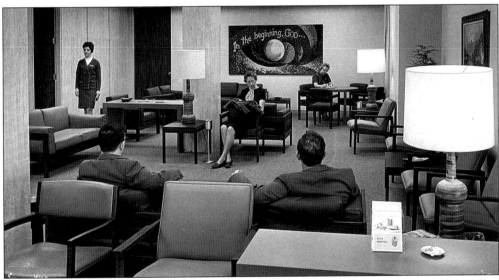

A massive fund drive was started in the late 1960s to raise money to improve and enlarge all of the city's hospitals. By 1972, Community Hospital had built a 220-bed addition, Lakeview General enlarged that facility to 167 patient capacity, the Battle Creek Sanitarium added the Jeffreys Building, and Leila Hospital constructed a $7.5 million, 227-patient addition. This photo from April of 1970 shows the Leila Hospital North Avenue lobby.

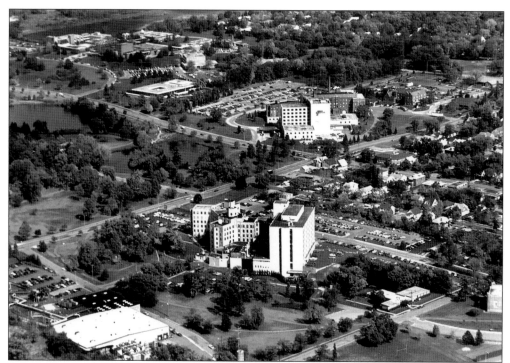

When this aerial photo was taken in 1988, health care was becoming more expensive and competition between area hospitals was increasing. Community Hospital (at the bottom of the photo) and Leila Hospital and Health Center (at the top of the photo) merged that summer to eliminate duplication, streamline services, and increase their purchasing power. The new entity was named Battle Creek Health System.

In 1988 the Community Hospital Association and Leila Hospital and Health Center joined together to create Battle Creek Health System. It was decided that all in-patient services should be combined at one site. The facility was built at the "Leila" campus for over $70 million and includes a completely new outpatient building (shown here in 2004), a physicians office building, the Cancer Care Center, and a remodeled main building (constructed in 1970 and on the far left of this photo) with a bed capacity of about 160.

116

Four
RELIGION

This undated photo is of the 1841 First Methodist Church that was located on the corner of Division Street and East Michigan Avenue, the site of the present city hall. Pew fees and money obtained by renting the facility as a school helped pay for the building. The abolitionist Horace Greeley spoke here in April of 1854. The building was sold to the Second Baptist Church and moved to a site on Marshall Street (now East Michigan Avenue) and Elm Street. (Courtesy of the Frances Thornton Collection.)

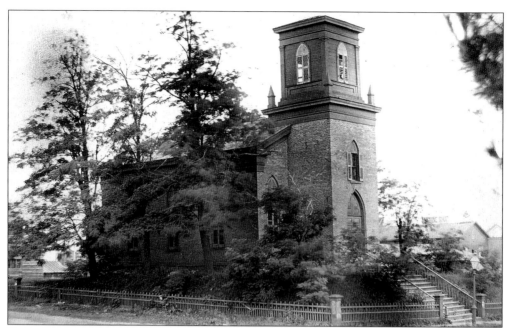

December 12, 1847 was the date of the first service held in this St. Thomas Episcopal Church on the southeast corner of Maple Street (now Capital Avenue Northeast) and Van Buren Street. The church shown in this undated photo was demolished in 1876 to make way for a new building. (Courtesy of the Historical Society of Battle Creek.)

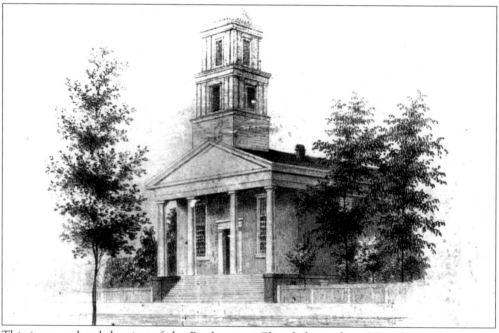

This is an undated drawing of the Presbyterian Church located on Main Street (now West Michigan Avenue). It was built in 1843 and burned in 1846. Its destruction provided the impetus to create an official fire department. A new building was constructed on the same site and opened in 1850. (Courtesy of the Martin Ashley Collection.)

In 1850 the new combined Presbyterian and Congregational church was built on Main Street (now West Michigan Avenue), on the site of the building that had burned in 1846. In November of 1883, after a theological disagreement, 66 members split from the church, formed a separate Presbyterian Church, and erected a building on the corner of McCamly Street and Main Street (now West Michigan Avenue). This photo from the early 1900s shows the businesses encroaching alongside the church. (Courtesy of the Historical Society of Battle Creek.)

The Congregational Church held services in this building until 1907, when they moved to the present church on Capital Avenue Northeast (seen on page 40). This structure was converted into the Garden Movie Theater then remodeled again to be used as retail space, as shown in this undated photo, and eventually demolished. (Courtesy of the Frances Thornton Collection.)

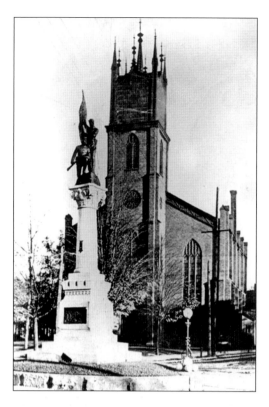

In 1858 the First Methodist Church built this structure on the east corner of Marshall Street (now East Michigan Avenue) and Main Street, the site of the present church. It contained the largest auditorium in the city and had the tallest steeple. Lightning repeatedly knocked the steeple into the street, until it was finally removed, as shown in this early 1900 photo, with the Soldier and Sailor monument, which was dedicated in 1901, in the foreground. (Courtesy of the Frances Thornton Collection.)

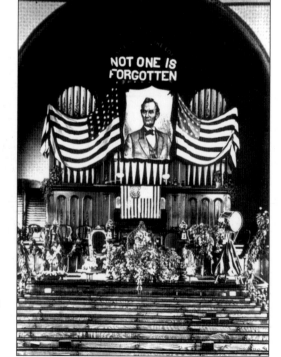

This 1885 image, made by Barr and Hampton photographers, is of the interior of the 1858 First Methodist Church decorated for a memorial service. (Courtesy of the Frances Thornton Collection.)

On July 4, 1876, the cornerstone for this St. Thomas Episcopal Church located on the southeast corner of Van Buren and Maple Street (now Capital Avenue Northeast) was laid and the building consecrated in 1878. This postcard from the early 1900s shows the English gothic structure of red brick and Berea-cut limestone trim designed by Detroit architect Mortimer Smith. (Courtesy of the Frances Thornton Collection.)

This 1878 Seventh Day Adventist Tabernacle stood on the northwest corner of Washington Avenue and Main Street (now West Michigan Avenue). It was also known as the "Dime Tabernacle" because when seeking money to have it built, Adventists from around the world were asked to donate one dime each month for its $26,000 construction. This postcard from the early 1900s shows the building prior to the January 7, 1922 fire, when it burned to the ground. (Courtesy of the Frances Thornton Collection.)

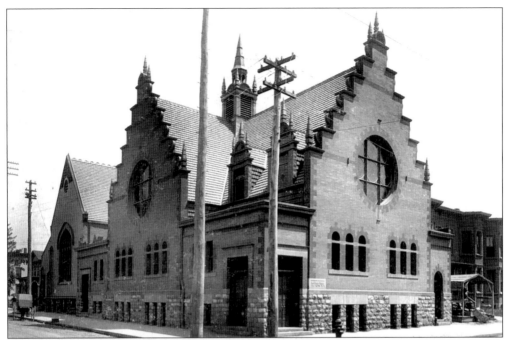

The Presbyterian congregation split from the local Congregational group in 1883 and built their church on the corner of McCamly Street and Main Street (now West Michigan Avenue). The original building is at the left in this picture. A new structure, shown here in this undated photograph, was dedicated in February of 1896. The building was demolished in 1928 and replaced by a J.C. Penney's store. (Courtesy of the Historical Society of Battle Creek.)

This photo, taken in the early 1900s, shows the interior of the Presbyterian Church located on McCamly Street and Main Street (now West Michigan Avenue). One of the features of this 1896 building was the use of bare electric light bulbs to illuminate services. The church contracted an electrical firm to come in each month to replace any burned out bulbs. (Courtesy of the Frances Thornton Collection.)

In 1843, Sands McCamly sold land on the south side of Main Street (now East Michigan Avenue) to the local Baptist congregation for the building of a church. The $26,000 brick building with a Joliet marble foundation was designed by William K. Loughborou and held its first service in 1872. There were originally two tall steeples which were removed after the northeast tower was struck by lightning in 1899. This postcard shows the structure in the early 1900s. (Courtesy of the Frances Thornton Collection.)

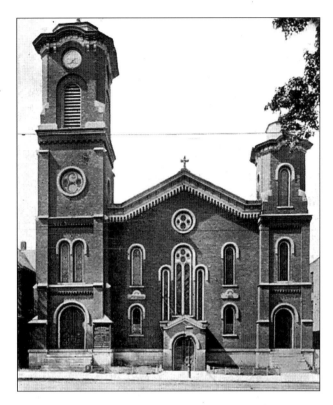

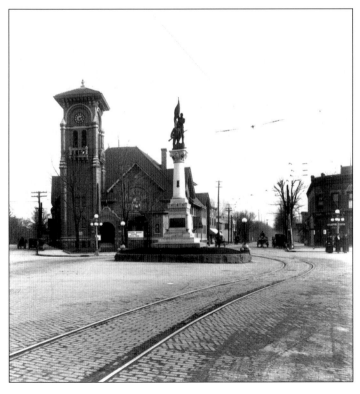

The First United Methodists dedicated this church in September of 1908. This photo from the 1920s shows the building at the intersection of Marshall Street (now East Michigan Avenue) and Main Street, also known as Monument Square. The structure seated 1,200 people in the sanctuary and was designed by Ohio architect Wilbur Thoburn Mills, who also designed the 1908 Battle Creek Central High School on VanBuren Street. (Courtesy of the Frances Thornton Collection.)

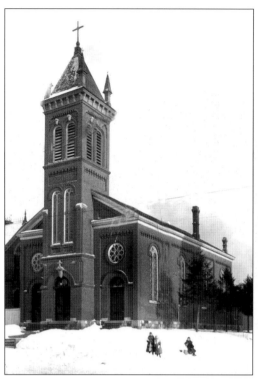

The first Catholic religious ceremony in Battle Creek was a wedding held on July 12, 1847. In 1860, the parish purchased a wood frame building on the northeast corner of Van Buren Street and Maple Street (now Capital Avenue Northeast) that had formerly been the Quaker meetinghouse. This undated photo is of the first brick St. Phillip Catholic Church on the same location, dedicated November 27, 1879. An addition was built in 1902, and the building burned on March 28, 1928. (Courtesy of St. Phillip Catholic Church.)

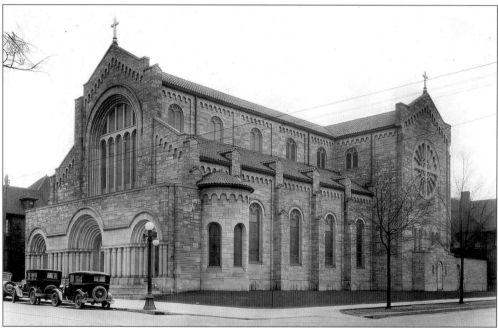

After the original church burned in 1928, this building was constructed on the same site. The stations of the cross, the altar, and some of the stained glass were saved from the fire and used in this structure, shown in this early 1930s photo. Architects Chute and A.B. Chanel designed the Romanesque edifice using yellow Bedford limestone; it was completed in 1930 at a cost of $200,000. (Courtesy of St. Phillip Catholic Church.)

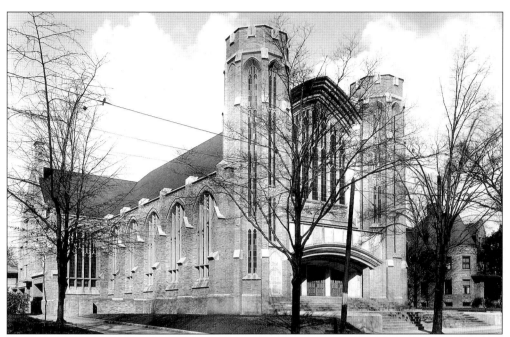

The First Presbyterian Church, shown in this early 1930s photo, is located at 111 Capital Avenue Northeast. Designed by parishioner A.B. Chanel, the $425,000 Norman gothic building was opened in 1928. (Courtesy of the Historical Society of Battle Creek.)

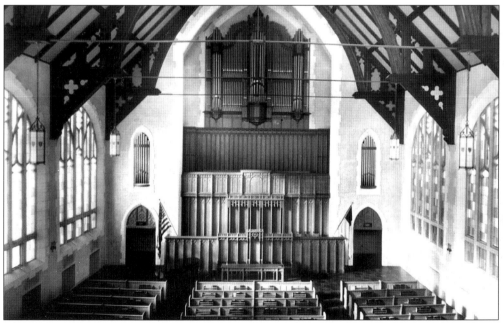

This is a 1930s photo of the interior of the First Presbyterian Church. The sanctuary has a seating capacity for 1,000 people. Behind this altar/choir loft is a four-story structure containing 32 classrooms, a dining room/kitchen, and a fourth floor gymnasium supported by five 32-inch diameter rolled steel beams that are 50 feet long to support the weight of the structure. (Courtesy of the Historical Society of Battle Creek.)

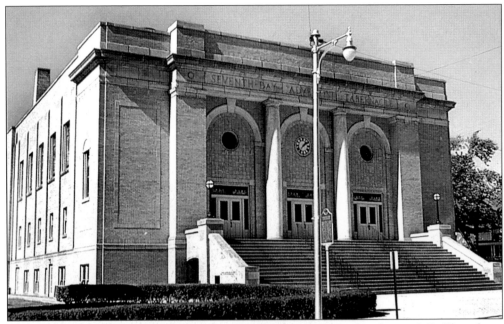

After the Seventh Day Adventist Tabernacle burned in 1922, local architect A.B. Chanel was given the job to design this building, located at 19 North Washington Avenue. The fireproof, $150,000 structure was dedicated October 9, 1926. This view of the building is from a 1950s postcard. (Courtesy of the Frances Thornton Collection.)

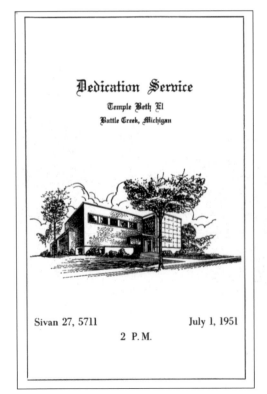

The first Jewish services in Battle Creek were held in 1880. In 1936 the first formal congregation formed. The Temple Beth El was designed by local architect Lewis Sarvis and was dedicated July 1,1951, as shown in this program from that service. The building is of Indiana limestone and is located at 306 Capital Avenue Northeast. (Courtesy of the Historical Society of Battle Creek.)

St. Joseph Catholic Church celebrated its first Mass in a renovated barn near 20th Street on January 1, 1942. St. Joseph Catholic School was opened on 24th Street shortly after that. This church, built next to the school, had its cornerstone dedication in 1954. This photo of the church is from the 1960s. (Courtesy of the Historical Society of Battle Creek.)

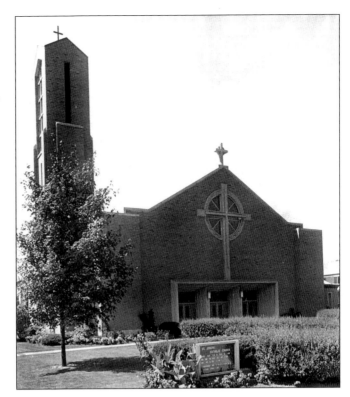

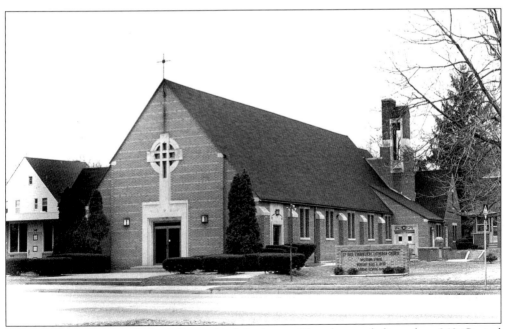

On October 16, 1949, St.Paul Evangelical Lutheran Church was dedicated at 349 Capital Avenue Northeast. The congregation continued to grow and a classroom/gymnasium wing was added in October of 1962. This photo was taken in the 1980s.

After many years of controversy over the 1859 city seal, the City of Battle Creek adopted this more sympathetic emblem as its logo in 1981, designed by Hilltop Advertising for the city's Sesquicentennial. (Courtesy of the City of Battle Creek.)

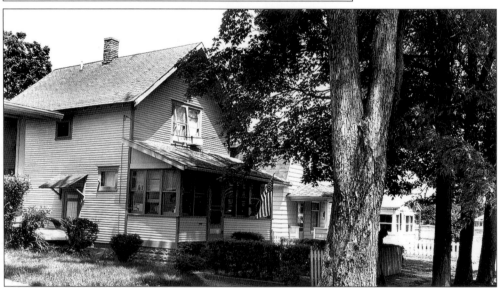

Using my authorial license I am giving recognition to my first Battle Creek history museum and classroom. This is the house at 118 Webber Street where I grew up. This was where my mother, Frances Thornton, a local history devotee, had long conversations with Berenice Lowe, a Battle Creek history author and icon in her own right. I heard stories of Mom's foster parents and how their families were settlers north of Battle Creek. She traded postcards at the dining room table with the Battle Creek Gas man who showed up monthly. She used the house as a base for collecting whatever Battle Creek books, pictures, postcards, clothes, and sometimes junk that was available. It wasn't an archival repository, but I'd be hard pressed to say it wasn't thorough. The house is gone but the memories linger on.